# PAINT TO PROSPER

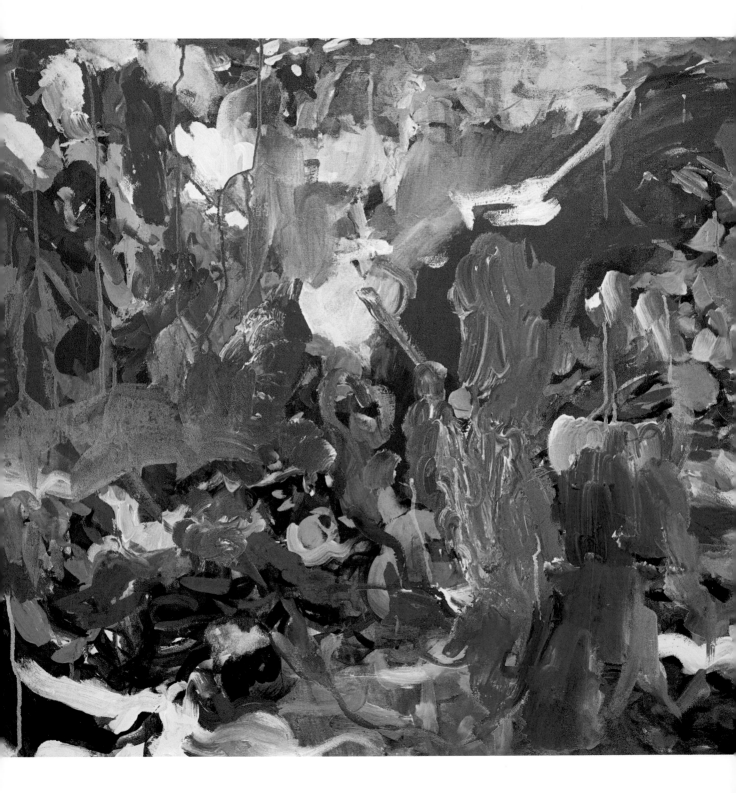

# PAINT TO PROSPER

## Transform Your Art Practice and Build a Modern Art Business

### AMIRA RAHIM

UNION
SQUARE
& CO.

NEW YORK

**UNION**
**SQUARE**
**& CO.**

**NEW YORK**

ISBN 978-1-4549-4637-3
ISBN 978-1-4549-4638-0 (e-book)

For information about custom editions, special sales, and premium
purchases, please contact specialsales@unionsquareandco.com.

Printed in China

2 4 6 8 10 9 7 5 3 1

unionsquareandco.com

Cover design by Igor Satanovsky
Interior design by Kevin Ullrich and Christine Heun

**Frontispiece:** Amira Rahim, *Telepathy*, 2022, acrylic on canvas, 30 × 40 inches.
All artwork and photos in book by Amira Rahim and
© Amira Rahim LLC unless indicated (see page 163).

"Where the spirit does not work with the hand, there is no art."

—Attributed to Leonardo da Vinci

# CONTENTS

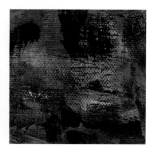

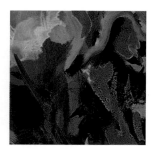

CHAPTER 1

## FINDING YOUR VOICE

CHAPTER 2

## COLOR MASTERY

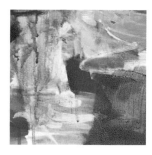

CHAPTER 3

## COMPOSITION 101

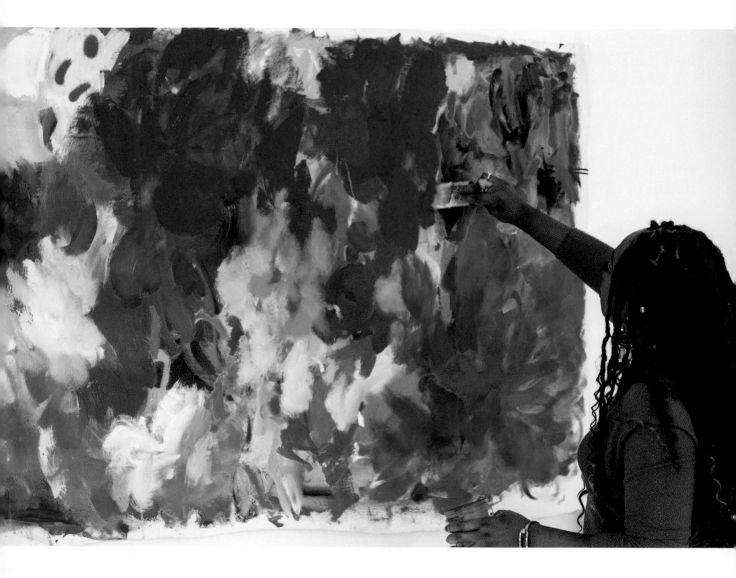

# Open Letter to My Creative Kindred Spirit

On this path, there will be many times when you will question if you should keep going. Even though you may feel that art is your calling, the obstacles along the way may seem insurmountable. I've faced these moments more times than I can count and while this book isn't about failing, I want you to know those moments hurt like hell. I remember crying myself to sleep at night after a "failed" exhibition to sell my original work. There were times I was overwhelmed with the logistics of delivering work safely and quickly enough to meet demands. Often, the stress took a toll on my mental health and I had to step away completely.

When I started pursuing my art full time at twenty-three, I was sure I would be a representational oil painter. I'd hustle in the studio from sunup to sundown trying to find my "style." I desperately tried figuring out how to make my still lifes and landscapes worthy of a glamorous high-price eBay sale, as I'd seen so many other artists do effortlessly.

Eventually, I hit a wall. I knew I loved painting, but something was missing.

Why couldn't the process of making art be as enjoyable for me as the finale? Why couldn't I have as much fun meeting my brand-new creations as a collector felt when they saw them for the first time?

I wasn't able to discover that level of ecstasy until I ventured off into the depths of abstraction. The first year was about learning to express myself more fluidly in color, without any judgment or expectations. Then, I was able to learn about the power of vibration and resonance through compelling compositions. My process was so intuitive that I could see my paintings when I would close my eyes at night. By the third year, I knew I had tapped into something that helped me become prolific, and demand for my paintings has increased year after year.

The results of those introspective years in the studio are ultimately what led to this book, *Paint to Prosper*. I am excited you made it.

*Windfall*, 2022, acrylic on canvas, 24 × 24 inches

# Introduction

This isn't a typical art book; I couldn't write this book without sharing what I believe is the true essence of all creativity—the soul. Our spirit urges us to continually explore new and challenging situations and it is up to us to rise to the occasion, growing new wings along the way. Art has been that rite of passage for me—the safe space for me to find wholeness again in a chaotic and increasingly crazy world.

My earliest memory of making art was when my mom signed me up for a children's art class downtown at the Newark Museum in New Jersey. I remember that the instructor had us sketch an egg propped up in front of us. I mean, we were five or six years old, rendering shadows, and I was fascinated with getting it perfect, like a magic trick. After class, when my mom met the teacher in the hallway, the teacher showed my mother the detail I included in the drawing and the skill I demonstrated. I still remember how proud I felt when the teacher praised my handiwork. And I think, from that moment on, I knew that making art was something I could call my own, and that would come to define my life.

For me, art was always something I did in seclusion. It was a private act. I would work painstakingly on intricate drawings, practicing my technique to refine an image to exactness.

Sometimes I would share them, but most of the time I felt content just knowing that I had the ability to "see" like an artist. Once I was introduced to painting at thirteen, I was hooked. The texture and colors of paints filled me with joy in a way that black-and-white pencil sketches couldn't. It gave me a place to explore my emotions, document memories that were important to me, and, most of all, it made me feel like I was no longer invisible—that I could overcome the shadows of a sometimes rocky childhood. I was now a devotee, and took extra art classes in high school and college.

The methodology shared in this book is rooted in a holistic approach to emotional recovery and healing, along with the practical knowledge that allowed me to paint more fluidly. Once I connected emotion to color, and composition to music, I began to "dance" with a confidence I could only have dreamed of in my college classes. The process is raw, bold, deliberate, and at times uncomfortable.

Whether you desire to create realistic art or dive headfirst into abstraction, finding your unique voice as an artist is priceless.

Since 2018, I've been teaching artists how to create high-value abstract paintings and to start growing their art business.

There are a few things that I'd like you to keep in mind as you work through this program:

- Unlike an online program with a definitive timeline, this book has no timeline. For some of you, this will be a relief. But for others, the open-endedness may lead to a lack of motivation. I suggest that you set a timeline for yourself of eight to ten weeks and hold yourself accountable. Write the deadline on your calendar and assign dates for you to complete each workshop. Consider enlisting someone in your life to be an accountability partner so they can push you to stay on track. Join the free Facebook group at https://bit.ly/painttoprospergroup.

- Don't just read the exercises—do them! That's where the learning really takes place.

- I strongly suggest that you follow the book in the order in which I've designed it, rather than skipping around. This book is built on a learning path that has a proven track record for success—but you need a guide through this journey.

Opposite: *Jellyfish in the Water*, 2019, acrylic on canvas, 36 × 36 inches

## You're on Your Way!

Congratulations! In undertaking this program, you've just taken a huge step. You're about to unleash the power of your voice by learning the most enticing ways to make people love your artwork. By going through this methodology, you will be able to confidently **charge a premium for your work because you will know how valuable your art is.** And, in doing so, you can make a full-time income doing what you love.

If you've struggled to make a sale online and you've only been able to sell your work to family and friends, or if you sell your work occasionally but you're tired of selling it so cheap—or if you're just not sure what's missing in your artwork—then you're about to unpack a distinctive formula for successfully attracting the right type of people to your artwork.

Even though it seemed impossible at one time, I could never have imagined that eventually I'd become a commercial success—simply by making some key paradigm shifts in my studio practice. There were a lot of tears, rejection, and outright embarrassing experiences since I decided to become a professional painter. But those obstacles ultimately became the fuel for me to learn how to build an art career from the ground up, with no fancy art degree or rich patrons.

So let's look at how this book will help you:

- I'm going to help you unearth what actually separates amateur art from professional art, and then I'm going to help you refine your style so that you know how to "steal like an artist" and not copy like a dabbler.

- Next, I'm going to show you, step by step, how to master color once and for all, so that you can produce vibrant paintings that are not *overly* colorful or loud.

- We're then going to dive deeply into composition. What most people don't realize when they look at amazing abstract paintings (any painting, really) is that 99 percent of the time, what you actually fall in love with is the composition. Color is an element of composition, but it is not the only one. Once you understand the foundations of composition and you learn how to apply them to abstract painting, you will be light-years ahead of most painters right now in the online market.

- As we dive deeply into the painting process, you're going to discover the essential ingredients to incorporate into your process. I use the word *ingredients* intentionally because in your studio it's like you're playing with this recipe and making it your own as you mix things up. I'll show you a process that's going to help you achieve greater depth, vibrancy, and interest in your paintings, so that you can attract more fans and ultimately the right type of customers for your artwork.

If you let it, this process can completely transform your painting ability, your trajectory as an artist, and the way you see your art.

## Your Art Matters—But What Does It Take to Become a Great Artist?

Your art matters! And through this program, I'm going to show you what it takes to become a great artist. When you think of how most people become artists, it generally comes down to two paths.

The first is going to college to get a fancy art degree that can cost you upwards of $200,000 and usually leave you with no real job prospects. Some art schools do not want you to even bring up the topic of marketing your work, and there's often no clear job trajectory unless you go the MFA route in order to teach. Outside of becoming a full-time art teacher, it's really difficult for art school graduates to figure out how to monetize their work. On top of that, many art students graduate without having a body of work that they're confident enough to start earning a living from. Not to knock art school, but it isn't a sure bet.

The other path is to try to learn on your own. Many artists spend year after year on local art classes, sometimes for decades, and still feel like hobbyists because nothing sells. Oftentimes, you pick up a few basic tricks, but then you kind of get stuck. It's easy to become completely dependent on a technique that you know how to do really well, but you might not have any clear understanding of theory or composition. In other words, your work can start to become tight and robotic. Boredom seeps in, and so does imposter syndrome.

But here is the good news: There is a **secret middle path**, which is having a dedicated studio practice, seeking out the right art mentor, and shortening the time it takes for you to go from

**"I want you to believe that you are a great artist—maybe you don't have the paintings in front of you right now, and maybe you're not making a full-time living with art yet, but I want you to believe that you can decide right now that you will become a successful artist."**

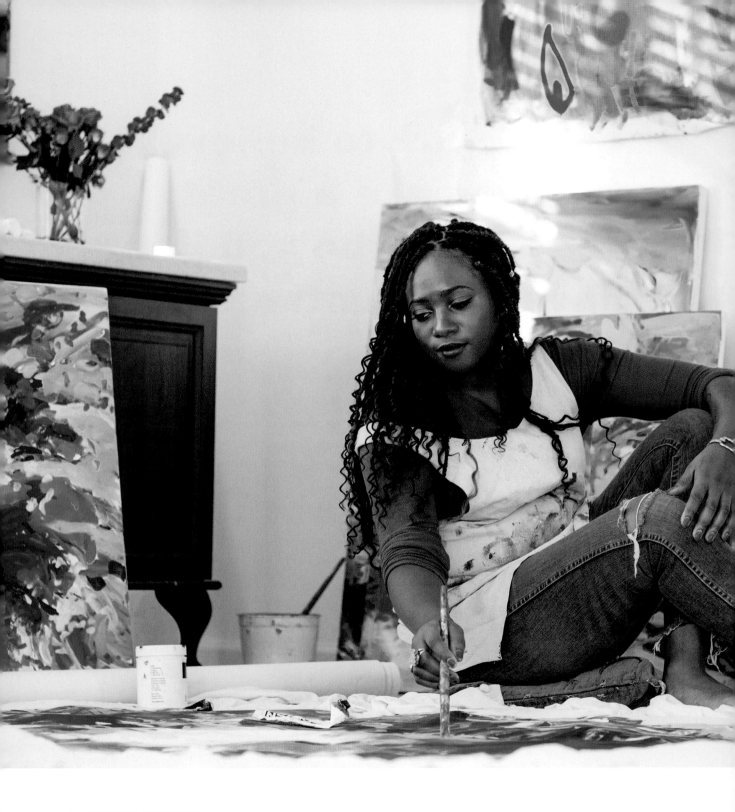

amateur to professional. That's the path that this book will take you on. Imagine this book as your own personal art mentor, equipped with exercises and "experiments" to amplify your painting expertise.

As you work through this program, you may run into some resistance. It may even be painful for you at some points, but know that this is refining your practice and it's ultimately going to make you the best artist that you can be.

Let's imagine that you've been looking at your dream art gallery online and you follow them on Instagram regularly. Now imagine stumbling across an update announcing that the gallery just brought in a new artist. This artist paints huge, sunny paintings that are priced higher than all the other artists in the gallery (and most artists in the market). You notice that this artist seemingly came out of nowhere and now your dream gallery is selling their paintings, not yours. And their paintings are priced in the tens of thousands of dollars. And you know what stings even more? When you look at their work, it's **really simple**.

The compositions are consistent. Even their colors are pretty repetitive. The work is clean—minimal even—and you know that in a different universe, you could do the same thing. You could probably be making that exact same work! So why did the gallery choose that artist—what did they do differently? I'll tell you: **The artist has simplified their painting process.** That's the first thing. And then because their process was simple enough, they were able to become prolific. This allows them to paint very quickly and very often. Last but not least, their work is to the point. It's

> **"What keeps me coming back is this human desire to be seen, to expose my innermost self and share her with others. Painting is my way of honoring my time on earth. It's my way of paying homage to the human experience. And it's a process that moves me every day."**

not overcomplicated; the artist isn't hiding behind complex details or perfect strokes and labyrinthine compositions.

Now for the good news: You can do this, too, and you will, with the help of this book. And there's no need to worry about whether or not you've gone to art school. Look at people like Frida Kahlo, Jasper Johns, Jean-Michel Basquiat, and Ai Weiwei. What do they all have in common? They either did not go to formal art school or left before getting a degree. This is not to say that art school isn't a viable way to become a professional artist, but I firmly believe that it is not the only way. With the right knowledge about art, a clear understanding of where your work fits into the market, and a formula to increase the value of your paintings, you can charge whatever you like for your artwork and you can earn a full-time income doing it.

These are the four key strategies we will cover:

1. **First we're going to get very clear on our style.** You're going to define your style. You're going to get clear on the difference between amateur art and professional art. You're going to look at your preferences and get familiar with why you like the type of art that you do. The same way you know within sixty seconds of hearing a song if it is your jam or not, that's the level of precision you need when it comes to knowing what you like and what you don't like artistically.

2. **Then as we transition into making a painting, we're going to explore color.** Along with theory, I'll share my own breakthroughs about color that have been game changers in my own abstract art-making process.

3. **As we go into composition, we're going to look at how to refine the composition process: the brushwork, the mark making, and the planning.** This will allow your painting practice to become more fluid because you're not stuck on WHAT to paint. You can instead focus on how good it feels to be tapped in and flowing with colors that excite you and movement that captivates your attention. I'm essentially going to hand you blueprints of how to create abstract paintings that have worked successfully for me. I can just pull examples and pull themes within my own body of work that have worked and that I can just re-create again and again and again because I have the process basically solidified in my head. Once you find and refine your own unique composition process, you'll be off to the races!

4. **For years, people have asked me, Amira, are your paintings oils or acrylics?** Many people assume I paint with oil paints because of how vibrant and rich the paintings look, even when viewed on a phone. I'll show you the exact recipe that I use to get these effects in my artwork—mixed-media techniques, such as translucency, texture, and many other tools, that you can use. This is going to increase the value of your paintings and you'll be able to start charging more for your work.

If you already have painting experience, you will be able to quickly incorporate each lesson into your process and start making better art instantly. But even if you don't have any experience, don't worry. I'm here to help you shorten the learning curve. Give yourself grace. Be coachable and have fun. Art doesn't have to be so serious ALL the time, am I right?

Let's get started!

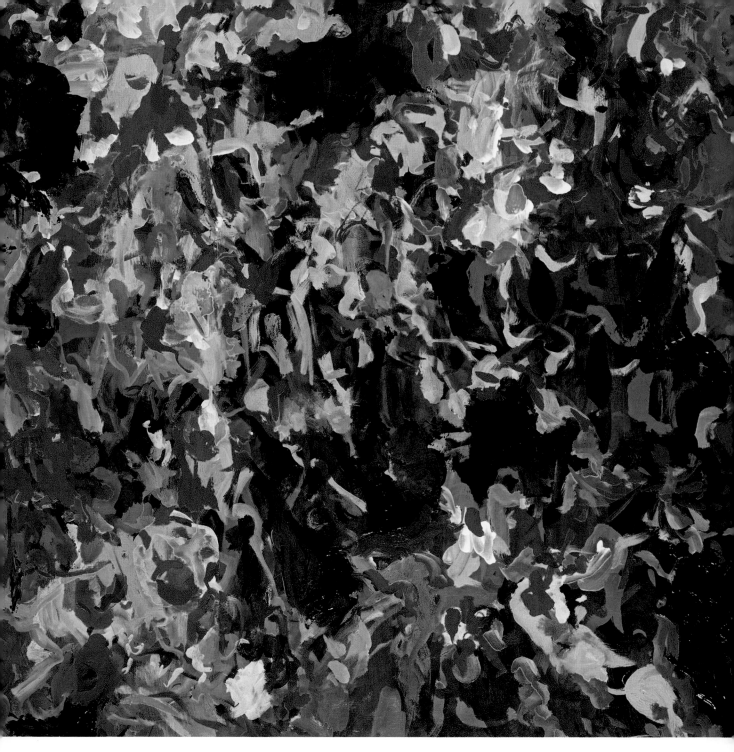

*It's Good to Be Alive*, 2022, acrylic on canvas, 30 × 40 inches

# CHAPTER 1
# FINDING YOUR VOICE

# WORKSHOP 1

## The Thriving Artist Mindset

I firmly believe that simply teaching you painting techniques is not enough. Without cultivating the right mindset, you won't be able to weather the many storms we face in the creative life. The artist's path is unorthodox, to say the least. We deal with our inner critic, our shadow side, inner child wounds, and rejection—often all in one day and online at that! Talk about daunting. I wouldn't be able to keep going if I did not take mindset work seriously. Developing the practices that I recommend will build your mental health as well as your career as an artist. We're going to transform the way you think about your art and make you into a mentally strong artist!

I found that locking down my mindset was pivotal in my own journey of transitioning from a hobbyist to a professional artist. It was actually the very first thing I started working on, and it's still the most important piece of my business to this day. I work on my mindset every single day, and you should, too.

I have my own set of coaches and mentors, and I know successful business owners (including painters), many of whom are millionaires. And the one thing that they all share is a powerful mindset. So if you feel as if you're slipping or you're having a hard time during the course of this book, remember this section and refer back to it.

So let me lay out the process to help you systemize your mindset work:

- **Become mindful of your internal dialogue:** This is crucial because no matter where we're from or how old we are, we all deal with negative internal beliefs about ourselves. We have anxious thoughts like *What if my art sucks? What if no one likes my work? What if I'm just no good at this? What if I can't manage my money? I'll never make it. It's too late for me. I'm too young. I'm too old. I'm too fat (or too skinny) to do this.*

Can I be honest with you for a moment? One of the biggest reasons I invested heavily in growing my social media following is this: When I first started selling my work online, I was afraid of making it to the gallery level and not feeling comfortable if I did. At the time I didn't know of any African American women who were selling art on the gallery circuit. Luckily, I did not let those fears hold me back. I was determined to carve out my own lane as a painter, gallery-represented or not.

- **Reprogram your subconscious through a meditation practice.** The subconscious mind is a powerful tool. When used correctly, you can manifest great transformation. But you must be dedicated. I will share some of my favorite ways to rewire my subconscious throughout this book, so when the going gets tough, you know how to come back to center and find your inner light. If you already engage in a meditation practice, great—you're halfway there. It's going to be very easy for you to meditate throughout this book. But even if you've never meditated before, I really want to encourage you to start meditating, preferably for a few minutes at the beginning of the day. It's really helpful for resetting your energy so that no matter what comes your way throughout the day, you're able to tap back in, center yourself, and stay grounded.

- **Develop a journaling practice.** As you journey through this book, you're going to uncover a lot of ideas, and it can be a very intense experience! Julia Cameron created the idea of morning pages for artists. This was a great tool for me at the beginning of my mindfulness practice. But as my life and business expands, I'm finding more and more that sometimes I love to do my pages at night. So "evening pages" can also become a great way for you to check in with yourself, celebrate your wins for the day, and release all that has come up for you while doing this inner work. It's very important that you have a place to let that out, and it may not always be on the canvas. Sometimes you're going to need to just grab a pen and paper and journal your emotions. Journal all these exciting ideas that you're having! I believe you're going to unearth new truths about yourself through this process, so I really want you to have a journal to capture that. You might even want to get a new one that you dedicate specifically for the work you'll unlock in this book, and you can just pull from it whenever you want.

- **Use sleep affirmations.** This is something that has been game-changing for me. Listen to binaural beats or meditations while you sleep—you can find many of these online, including focused ones on topics like money beliefs and confidence. As you listen to these while you sleep, it's actually reprogramming your subconscious mind.

> " We all have limiting beliefs that we tell ourselves and the faster you can start becoming mindful of them, the faster you can start to rewire your brain and change the internal conversation that you're having every day. "

- **Learn from the masters.** I want you to understand that every single artist you know of is inspired by someone else, and we all start out as beginners. Some of us master one subject, and then go on to become beginners all over again in another. It's really helpful if you can draw your inspiration from the masters instead of drawing inspiration from what's out there currently on the internet. This is going to help you be **inspired, instead of intimidated**, which is a big shift for most of us. There's enough regurgitation out there as it is and I can tell you after coaching hundreds of artists, digging deep early on in your practice will help you immensely. Throughout this process, you're going to collect tons of inspiration from many different types of artists who have gone before, allowing you to draw from that **well of inspiration** anytime you want. I can't wait to show you exactly how.

- **Believe that your art can be profitable.** This is huge. If you're struggling with ideas like *I'll never be able to make money with art*, or *People just don't spend money on art*, then you can seek out examples to refute these thoughts. For instance, look at auctions to see evidence that art is a commodity that people actually pay for. All artists need to constantly work on our wealth consciousness. This is something that I actively do multiple times a week, multiple times a month, multiple times a year. It is crucial for us as artists as we're forging our own path. Early in my art career, I had the privilege of coming across the book *A Happy Pocket Full of Money*, by David Cameron Gikandi. This book completely changed how I operate as a human being. I relisten to the audiobook version almost every year. I strongly advise you to read this book. ■

# 15 Positive Affirmations for Artists

We all need help along the way! When you need an intuitive nudge, borrow these affirmations that my students and I came up with one day for inspiration.

1. I allow myself to paint for the joy of the creative process itself.

2. I find meaning and purpose in my work each day.

3. I am surrounded and supported in my artistic endeavors.

4. I am open to receiving grace and divine healing from my higher power, whatever that may be, through my artist journey.

5. I am exactly where I need to be in my business and creative process.

6. I embrace the present moment.

7. I am allowed to paint for joy.

8. I paint because it's challenging and exciting.

9. I inspire greatness in myself and others.

10. I am loved.

11. I am celebrated and my work is celebrated.

12. Money comes to me easily and frequently.

13. I am open to receiving. There are no limits on where support comes from.

14. I am resilient. I embrace my struggles and mistakes to develop my strength.

15. I prosper wherever I turn.

# Journaling/Visualization Prompt

Taking time to nourish and replenish our subconscious mind is vital to succeed at this work. Consider the following prompt as an example of the healing power of reclaiming your attention, getting back in touch with your body, and harnessing the power of your imagination for a positive outcome.

1. Get in a comfortable space, free from distraction.

2. Grab some grounding scents, such as palo santo incense. The subconscious is powerful, and, as you create sacred ritual around your art practice, your confidence will expand into your work.

3. Quiet your mind and envision a light forming in front of you. Notice what color this light becomes. That may be an indication of a chakra (energy center) that is calling for more attention. Or it can become a color inviting you to incorporate it into your painting today.

4. As this light becomes clearer, imagine it subtly traveling through your body. Let it start from the top of your head and go through your spine. Next, envision it expanding into your heart center, your core. Notice energy moving through your lower back at the base of your spine and through your feet. Breathe deeply as you tap into your infinite source.

5. Now that you are still, imagine that you are living your dream.

6. Set aside some time in your schedule to visualize how you're going to feel when you're living your dream life. What is that going to look like? Maybe you can visualize what type of schools you're going to send your kids to using the money you earn from your art. What organizations do you want to donate to? Or maybe you want to start an organization or a foundation of your own! How do you want to spend your days? Are you going to wake up early or go to sleep late? What companies are going to buy your art? Choose the companies you're going to work with, no matter how far-fetched it may seem right now. The more you can visualize your dreams, the more they can become a reality. And you'll be able to pat yourself on the back when they start to come true, because you'll see clearly how you visualized that reality and then made it happen through hard work.

7. After you've experienced this newly channeled energy, write down your thoughts and visualizations in your journal. Maybe you want to set a new goal for yourself and actually commit to it. Maybe it's a beautiful affirmation that you realized you're ready to speak into existence. Whatever it is, put it in writing so you can come back to it later. Envision that these goals and visualizations will manifest into reality. Trust that what feels out of reach now will soon become a fond memory in the future. Even if you can only visualize for a few minutes at a time, don't get discouraged. Your ability to expand your imagination can strengthen with regular practice.

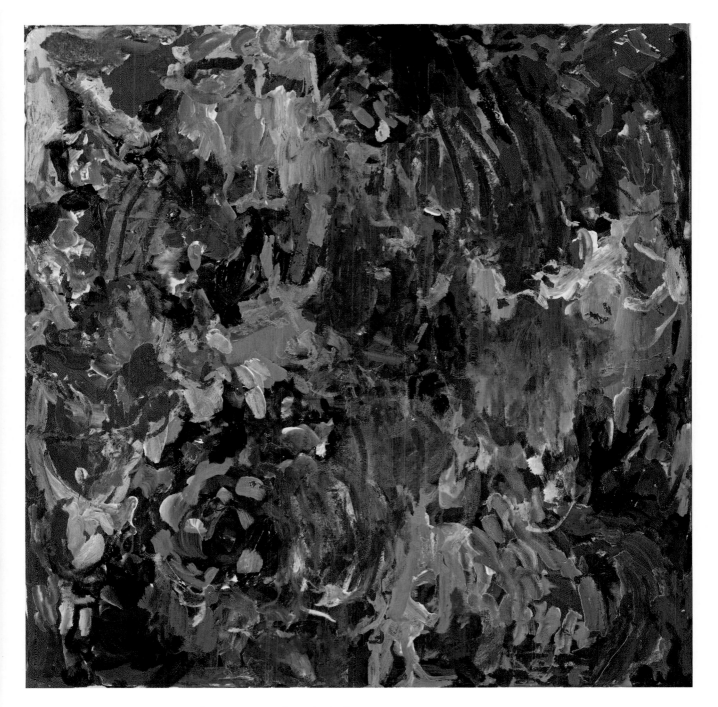

*Sunny Escapes*, 2022, acrylic on canvas, 24 × 24 inches

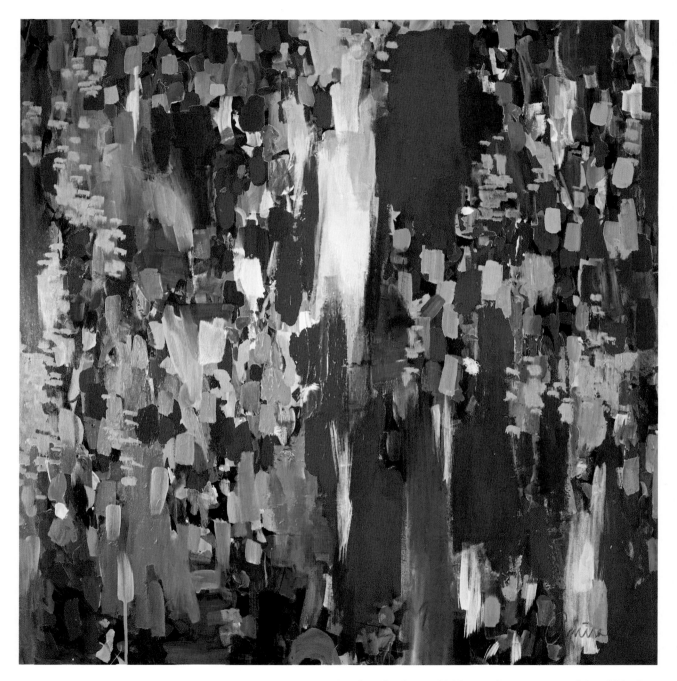

*Bright Like Stars*, 2022, acrylic on canvas, 36 × 36 inches

# WORKSHOP 2

## How to Steal Like an Artist

So why are we starting a painting book with "stealing"? What is the point of this? Well, first and foremost, it is a humble request to not copy my own work and sell it for profit. It's embarrassing for both of us when an artist messages me alerting me of another rip-off attempt. As a full-time selling artist, I protect my work and the interests of the licensing companies that distribute my original creations. I've even had collectors tell me "Amira, stop teaching artists your secrets. You're crazy for giving this away when your work is so good right now and in demand." Well, part of my motivation in teaching other artists is that I want to channel my experience to others. It is inherently mine because I learned how to access these codes. I am sharing these codes with you in good faith because I wish someone had laid out these concepts to me when I decided to become a professional painter. Even with decades of painting and drawing under my belt, finding my voice and creating in a way that felt expressive was difficult. I had to dive in headfirst. I emerged a few years later, a bit bruised, but happy.

There are three core values that guide the focus of this material. This is reflected in the way I teach and the expectations set for you now. The three values are listed below; please recopy them on a page in your journal. Then sign your name and add the date underneath, to acknowledge your understanding of these values.

1.  **Innovation:** My painting practice became fun once I stopped looking for permission from others who had "made it" and started experimenting with new materials and habits. In order to have unshakable confidence in your art style, you must be willing to innovate. This doesn't happen overnight, but I believe it is a guiding principle to be remembered in our line of work.

2.  **Curiosity:** Adopt a healthy level of curiosity, both in your painting practice and in your business. No one can guarantee the outcome of almost anything. But when you're at least curious enough to see what you're capable of as an artist, you will always learn.

3.  **Integrity:** Try not to plagiarize. Try not to rip off other people's hard work. Try not to be a jerk. Sounds simple—LOL. But, in all seriousness, there's a lot that emerges when you decide to go pro and be a full-time artist. Integrity may be a lonely, arduous path, but, in the end, I think it

keeps your work pure. And when it doesn't align anymore, be brave enough to adjust and move to the next iteration.

A quote apocryphally attributed to Picasso says: *Good artists copy. Great artists steal.*

For a while, I didn't really understand what this meant. It wasn't until I read Austin Kleon's book *Steal Like an Artist* that I more fully understood the quote. In this book, Kleon talks about how nothing under the sun is truly original, and that there are good ways to be an artist inspired by others, and bad ways to be a thief.

- A good "thief" respects another artist's work, while a bad thief debases it.

- A good thief studies, whereas a bad thief simply scratches the surface.

- Good artists "steal" from numerous sources, while bad artists steal from one.

- Good theft gives credit where credit is due. Bad theft plagiarizes (which is why copying other painters' *finished compositions* for profit feels so gross when you see it happen).

- Good theft transforms or remixes an idea, whereas bad theft just imitates it and truly steals it.

Take a page out of Kleon's book, literally. Let's see what this means for us as we dive into abstraction.

## STUDY THE MASTERS

Below is a list of my FAVORITE expressionist painters. I recommend googling their names and studying their work in conjunction with this book. Use their work as a springboard to research what interests you, as I explained in the previous section. I've pulled a few of my favorite quotes from each of them to really cement the values and ideas you will soon learn in *Paint to Prosper*.

■

### RICHARD DIEBENKORN

*"If you get an image, try to destroy it."*

*"All paintings start out of a mood, out of a relationship with things or people, out of a complete visual impression."*

■

### WASSILY KANDINSKY

*"The artist must train not only his eye but also his soul."*

*"Color is the keyboard, the eyes are the hammers, the soul is the piano with many strings. The artist is the hand that plays, by touching one key or another purposively, to cause vibrations in the soul."*

■

### JEAN-MICHEL BASQUIAT

*"I don't think about art while I work. . . . I try to think about life."*

*"I want to make paintings that look as if they were made by a child."*

■

## MARK ROTHKO

*"We thus see the artist performing a dual function: first, furthering the integrity of the process of self-expression in the language of art; and secondly, protecting the organic continuity of art in relation to its own laws. For like any organic substance, art must always be in a state of flux, the tempo being slow or fast. But it must move."*

■

*"I think of my pictures as dramas; the shapes in the pictures are the performers. They have been created from the need for a group of actors who are able to move dramatically without embarrassment and execute gestures without shame. Neither the action nor the actors can be anticipated, or described in advance. They begin an unknown adventure in an unknown space."*

■

## JOAN MITCHELL

*"Abstract is not a style. I simply want to make a surface work. This is just a use of space and form: it's an ambivalence of forms and space."*

*"Sometimes I don't know exactly what I want [with a painting]. I check it out, recheck it for days or weeks. Sometimes there is more to do on it. Sometimes I am afraid of ruining what I have. Sometimes I am lazy, I don't finish it or I don't push it far enough. Sometimes I think it's a painting."*

■

I recommend searching for even more artists who are no longer living, and studying their work and their words. It's so easy to get caught up in the trends, but remember: Each era birthed the next. Look into Impressionist artists and explore art from different countries—even prehistoric cave paintings. ■

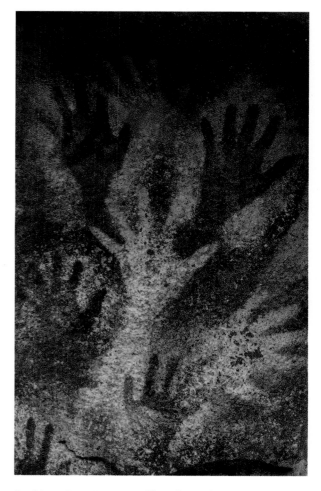

Prehistoric paintings of hands at the Cueva de las Manos (Cave of the Hands) in the province of Santa Cruz, Argentina, c. 5000 BCE.

# WORKSHOP 3

## Decide What Your Unique Contribution Will Be

I didn't plan on being a full-time artist, even though I took art classes for years. In college I was focused on social research. I was passionate about research and I felt torn between either becoming a social scientist or going to law school. Spoiler alert: I did neither—LOL.

But little did I know that my background in research would give me a competitive advantage when I decided to become a full-time artist in 2013! I was able to quickly assess the art that was on the market, what my strengths and weaknesses were, and how I could stand out in a crowded marketplace. This alone is how I was able to garner lucrative licensing deals in a relatively short amount of time on the art scene.

I want to share with you a key concept from my research, and that is **your unique contribution**. This is something that my professors drilled into my head. I spent three years creating an honors thesis, collecting actual quantitative data, and running statistical analyses to back up my ideas. But the very first thing I had to do was determine what would be my unique contribution. I had to review *alllll* of the literature on this topic as thoroughly

as I could, including the angle of research that I wanted to explore.

**Good for you, Amira. Now what the heck does this have to do with selling art?**

Have you ever wanted to paint but stopped yourself simply because of how overwhelming it is looking at all the other art out there? Do you lament about how "saturated the market is"? Or how many people are doing the SAME DAMN thing already? It can make you decide to give up on your talent altogether. What's the solution?

You have to figure out what YOU bring to the market that's a fresh perspective. And then stand by with confidence knowing you have an actual context around which to frame your art.

You're going to now start to define your style by asking yourself a series of questions as you go through the process of looking at a lot of art. Like a lot. You will be absorbing a ton of paintings fast and documenting what you like. To organize and keep track of this process, I recommend Pinterest. To help isolate your influences, you can visually organize all the art that catches your eye, create boards for innovative use of materials and brush techniques, or even just pin inspiring color.

I recommend narrowing down some influential paintings to about thirty to forty pieces. Next,

list the elements of art that you like about each painting, even if you don't know the fancy, proper art terms for it. You can leave notes right under the pin itself. As you look at a piece of art, ask yourself these questions:

- Do I like the **colors**? What are the color combinations that most excite me right now?

- Do I like the **texture**? What is it about the texture that I like? Is it thick? Does it make me feel a certain way? Do I want to try this texture? Do I want to touch that painting?

- What about the **materials**? Do I like how these materials look? Do I feel drawn to use some of these materials in my own work?

- How is the **composition** organized? Even if you don't understand exactly what composition is yet, just ask yourself where your eyes move across the painting. Do you like how it's organized? Does it feel chaotic? Does it feel really orderly and straight and narrow, or is it messy and all over the place? What catches your eye at first glance?

- What about the **brushwork and the mark-making**? How do the movements make you feel? Like the painting is dancing off the page? Does it give you a certain energy? Do you like how that energy looks inside the painting?

- What about the subject matter? Maybe you look at a painting and you say to yourself, I've always had an affinity for flowers. So when I see this painting, it really makes me want to paint them, too.

- You could also be drawn to the **pattern**. Do you notice any tick marks, dots, dashes, or things like that?

Ultimately, you will ruminate on these notes. It may take weeks or come to you instantly. But there are two ways to make a unique contribution:

1. Find gaps in what is currently in the existing body of art out there (the existing canon). Discover where the holes are, where something's missing. This might include trends, subject matter, market, style—whatever the case is, you're going to seek a gap that your work can fill.

2. The second way is a little more nuanced. It involves creating a unique combination of elements that are already in the canon and marketplace. By merging two or more of these ideas, you'll come up with your own unique art offerings. This mix and match is what Austin Kleon means when he talks about "remixing."

## SYNTHESIZE

You're going to ask yourself these questions for every single painting that you can, and then you're going to start creating a list. Once you have this list, you can start to isolate some of these elements and combine it all. In other words, you will begin to distill down and synthesize your preferences.

The more specific you can get about what you like and don't like, the closer you can get to developing your unique voice as an artist. It will also help you clearly articulate your vision to others and why your voice matters. I like the idea of having this secret board of inspiration, available for me to pull from when I'm ready to paint. And with enough time, these observations become lodged in your subconscious. You won't need to pull up photos on your phone; you can just paint from your soul, paint from your gut, and paint from your heart.

This methodology also reduces the risk of creating derivative art. No one wants to have their work look like a second-grade version of someone else's. We want our art to actually look like our own and we want to get better over time. We want to be able to advance. ■

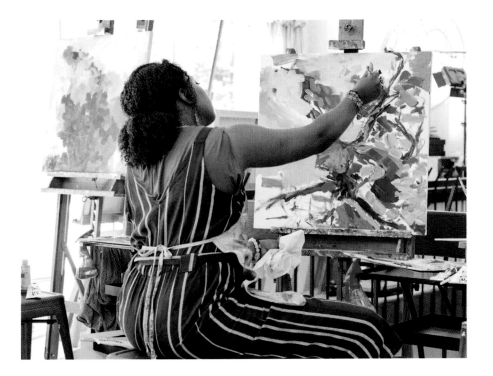

Working on a demo painting during one of my workshops. I discovered that figuring out how to bring a fresh perspective to the market, so I could stand out in a crowded field, was a key step to success.

# EXERCISE
## Isolating Your Influences and Synthesizing Your Style

Now that you've begun looking at art and identifying what you like, we're going to create a private board in Pinterest for you to organize and draw from your inspiration. Here are the steps:

1. If you don't already have a Pinterest account, create one.

2. Create a private board and give it a title that speaks to you, such as "Abstract Inspiration."

3. Begin searching for examples of art that have something that attracts you. You have my full permission to sit on your couch and dive down the Pinterest rabbit hole. You can search the names of artists (including the ones I suggested in the last section) or terms like *abstract landscapes* or *abstract florals*. Once you get going, you'll see that Pinterest starts to suggest images based on your activity, which can be a great way to discover new influences!

4. Don't simply create your board and call it a day. In the comments section of each image you pin, write a note to yourself describing exactly what it is about the artwork that attracts you (see page 23 for suggestions).

5. Find more quotes from artists who inspire you and write them down in a journal.

Also note down and answer the following seven statements in your journal:

1. When it comes to color, I am particularly drawn to:

2. Elements of composition I'm drawn to include:

3. The brushstroke style I most enjoy looks like:

4. I like when paintings make me feel:

5. I really dislike when I see this in a painting:

6. Some of the artists whose work I came across during this exercise whom I want to remember in the future are:

7. Some art materials that I think would be cool for me to experiment with in new paintings include:

Congratulations—you're on your way to making your unique contribution!

## A NOTE:
# Mental Health and Creativity

Since the beginning of my journey selling my art online, I've tried to be as vocal and transparent as I can about mental health awareness. It's no surprise that this topic, though delicate to approach, is an important one in our creative community. In public, we may manage social media profiles, manage clients and customers, and garner accolades that make others swoon. But behind closed doors, we are still human beings dealing with inner child wounds and trauma, like everyone else.

## CAN YOU MAKE ART WHEN YOU'RE SAD?

You may be surprised to learn that my ongoing struggles with low-level depression are what led me to commit to a regular art practice. Even though my art is happy and upbeat, it's really a response to my own self-work: to not succumb to sadness and to live in the present moment. I've had to give some real consideration to how my social media posts and branding could provide a false narrative if I'm not transparent about my mental health struggles.

I'd never want someone to go to my Instagram feed and assume that my life is perfect, or that I'm having the time of my life all the time (although many days I am, indeed, jumping for joy and pinching myself at the fact that I get to live out my childhood dream of being an artist). I didn't like the notion that I was immune to pain and real human stuff happening to me.

Just like my art, my happiness and inner balance is a daily practice. And depression is something I've learned to accept as just one part of how I am wired. It took a long time for me to come to that acceptance because I thought it was just my personality. At least it blessed me with a dark sense of humor, right? After living in Abu Dhabi for six months, I reached a real low as I found myself lonely in a new country; also my partner at the time was facing a severe health crisis and we had no extended familial support. I was terrified and no fun to be around. By the end of that first year in Abu Dhabi, I had to seek help, adjust my outlook, and dive headfirst into the one thing I could control: my art.

The hard work paid off, and the clouds began to lift again. But then came the anxiety. Living in the Dubai/Abu Dhabi region, a place where everyone's trying to be the next big mogul and anything's possible, fueled my anxiety. I would look out my window, thirty stories above the ground, and stare into a 100°F abyss of opportunity. I was startled with the idea of sitting still. Disgusted with the possibility of leaving the country without leaving my mark,

> ## "You can indeed get through your darkest moments. You may have dry spells and downtime. But you are still an artist. "

without doing anything other than shopping (and in the UAE, shopping in the breathtaking, world-renowned malls can keep you quite busy). It wasn't enough. (Read: *I wasn't enough*).

I was able to shake off much of my depression. I'd feel it coming on and I'd do things to lift my spirits. Mostly create art, listen to podcasts, etc. But like an old friend, the depression and anxiety were still waiting by the phone for that familiar conversation of loneliness, self-loathing, and pessimism. I tried to keep them at bay with accomplishments: More art sales. More shows. More press. Pushing past new limits of health and balance. Anything to leave them in the dust. I even thought that so much of my anxiety was because of that dusty, desert metropolis itself. Moving back to the United States seemed like the right solution.

But the politics, horrifying news flashing across our screens on a daily basis, took its toll. And then #BlackLivesMatter in 2016. And again in 2020. And the pandemic. And social isolation. And like a true loyal friend, depression came back to visit. Getting out of bed felt pointless. Suddenly, I couldn't deal.

The difference in how we handle depression and anxiety can sometimes come down to seeking help and learning to observe these emotional states, rather than identifying with them. I am not my fears and my anxieties. I am not even my story. They remind me of how strong I am. Not of how weak. In 2021, when I lost my grandmother, I was introduced to a whole new level of grief. You can't spell painting without *pain*, I told myself. I knew I needed to take a proper rest from pressures I put on myself in my business.

We all have painful things in our lives that we must deal with. Don't fall into the trap of wishing, even for a moment, that life would be better if you could trade lives with the people you see online or on TV, or those close to you, because no one goes through life unscathed.

So can you make art while you're sad? Yes. While you're depressed. While you're hurting for the world. While you're exhausted. While you're barely hanging on for dear life. We can make art when we're sad, but let's not make that the norm. I am an advocate for mental health because of what I've experienced. And I know that no matter what records or milestones we give ourselves to be artists, we also must be excellent stewards of our mental health. Unplug from social media. Safely seek the help that you need professionally, medically, and spiritually. And know that there's a place for you here.

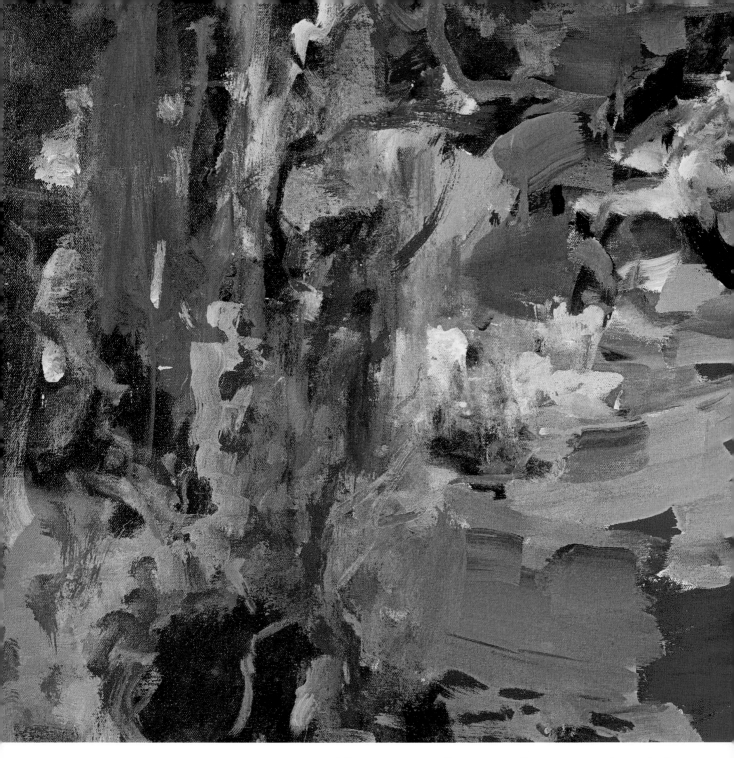

*Heat of the Moment* (detail), 2022, acrylic on canvas, 24 × 24 inches

# CHAPTER 2
# COLOR MASTERY

# WORKSHOP 4

## Starting with Color

We're about to dive into color, and you may wonder if you have the right paint colors on hand—because we're going to get hands-on right away. Here are the paint colors I recommend for this program. They're my holy grail of colors, allowing you to create almost every color you'll need:

- Quinacridone magenta (transparent)

- Viridian green (transparent)

- Prussian blue (transparent; called Prussian blue hue by some brands)

- Cadmium yellow medium (opaque)

- Cadmium red (opaque)

- Titanium white (opaque)

- Phthalo blue (transparent)

- Dioxazine purple (very strong tinting power—a tiny bit goes a long way)

Please note that these are color names used by Golden and Liquitex brands (the same names are used by many other brands, too, and also for many brands of oil paints and watercolors). If you are using colors produced by other manufacturers, that's okay. Those may give you slightly different results, which is why we'll be color-swatching later in this chapter.

You are welcome to use additional colors outside this list. I find that these colors have become my staples, and I want you to have the ability to mix the colors you want to use without having to buy every color in the rainbow. I'll be sharing more fun additions, like fluorescents, later in the book as well.

# Useful Terms for Talking about Color

Before we go further into color, let's identify some
useful terms so we're all on the same page.

**VALUE:** The difference between darks and lights. Black is the darkest value, but can be substituted with Prussian blue or dioxazine purple for more colorful results. White is the lightest value. Remember: Your eyes see value before they see color, so create strong value contrast.

**NEUTRAL:** A color that has been muted or "grayed down." This can be achieved by mixing a color into its opposite (see Complementary Colors, right); such neutrals can be further made cooler or warmer by adding cool or warm colors. I like to incorporate neutral negative space in a painting to provide a nice backdrop or foundation for more saturated colors (see below).

**SATURATED COLORS:** The colors (or hues) as shown on the color wheel. Saturated colors tend to come straight out of the tube. They work best when used in balance with more muted tones and negative spaces (see below for more on negative space).

**TRANSLUCENT:** Referring to colors that allow light to penetrate through them. Check your paint tubes or do a manual test to see how translucent your colors are. It is best to start your paintings with translucent colors and then layer afterward with opaque colors. Translucent colors play nice with other colors.

**OPAQUE:** Referring to colors that do not allow light to penetrate through them. Adding titanium white to any color will make it opaque. The number one reason people make mud is because they are mixing opaque colors together, making the hue less and less vibrant. Here's another way to think of this: Opaque colors do not get along well with other colors.

**COMPLEMENTARY COLORS:** Colors that are on the opposite sides of the color wheel from each other: red (or magenta) and green, yellow and purple, orange and blue. See the color wheels on page 33.

**NEGATIVE SPACE:** In a painting, negative space is empty space on a canvas that gives the eye a place to rest. It's a good idea to incorporate negative space in your paintings to keep them from looking too busy or overwhelming. You can achieve negative space with any solid color, not just white. It can be dark or light as well. Think of the vast sky and trees. Or a dark sky at night against the moon and stars. The sky is the negative space.

# Learning the Difference between RGB and CMYK

In this lesson, you will learn the difference between RGB and CMYK color wheels and how to apply them in your paintings. Rather than focusing too much on color theory terminology, like tints and shades, I want to focus on *learning how to create and use colors in your work.*

Traditionally, color has been defined by the **RGB** model (**R** = Red, **G** = Green, **B** = Blue). However, the more modern approach of **CMYK** (**C** = Cyan, **M** = Magenta, **Y** = Yellow, **K** = black) is now used to get the vibrant, wide range of colors that we use today.

Although RGB and CMYK are color-printing terms, you only need to know one key thing: what happens when you use red in your color wheel versus what happens when you use magenta.

In the example below, I use quinacridone magenta. I use this color for 99 percent of all the pinks and reds I incorporate in my own work.

## Create a Color Wheel Including Red

To begin our color wheel process, we're starting off with the traditional use of cadmium red as the primary "red." **Resist the urge to simply look at a color wheel, rather than actually creating it yourself.** You learn so much better by doing it yourself, and I want you to become a master at bending color to your will. I realize that you may have created color wheels in school, but do

it again with me right now. You will experience the biggest aha moments by doing the exercise below manually. (Note: When changing paint colors, particularly from one side of the color wheel to the next, be sure to change or clean your brush!)

1. Draw or trace a blank color wheel. You can search for a printable color wheel online or simply draw your own on white cardstock. Grab a paintbrush with short bristles as well as some red, blue, and yellow paint.

2. Start by painting in the primary colors: red, blue, and yellow. If the color wheel were a clock, imagine that the red goes in the 12:00 position; the blue goes in the 8:00 position and the yellow goes in the 4:00 position. Here I am using phthalo blue, but you can experiment with different blues, such as cobalt blue, ultramarine blue, and so on.

3. Mix red and yellow in varying degrees to create red-orange, orange, and yellow-orange, and apply them to the 1:00, 2:00, and 3:00 positions.

4. Then mix yellow and blue to create yellow-green, green, and blue-green, filling in the 5:00, 6:00, and 7:00 positions.

**5.** Finally, mix blue and red to create blue-violet, violet, and red-violet for the 9:00, 10:00, and 11:00 positions. This is where things may start to go **wonky**.

Here's another example of some "purples" I was able to mix with red. Are you having a hard time mixing up a solid purple? It may even turn a muddy brown color, right? That's exactly the discovery I want you to have.

One of the drawbacks of working with an RGB color wheel is that it's tough to create a true purple. You can try adding titanium white to it to brighten it, since white illuminates. But too much of the white, and it desaturates the color altogether.

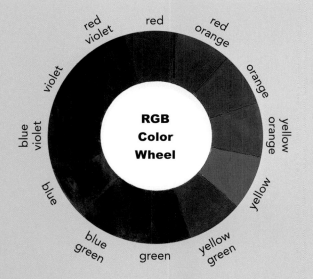

Take a look at your completed color wheel. Notice how the right side of the wheel feels vibrant, but the left side is a bit dull. We'll be contrasting this with the CMYK version of a color wheel next.

## Create a Color Wheel Including Magenta

Next, you're going to take a second blank color wheel and fill it out—but this time, you're going to replace the red with magenta (preferably quinacridone magenta). All the other colors should be the same as the ones you used for the first color wheel.

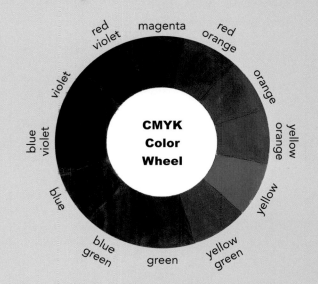

The revised color wheel, showing the reds replaced with magenta

What do you notice? Obviously, the parts of the color wheel that are solely derived from combinations of blue and yellow remain the same. But there are variations in all the areas that involve magenta.

After completing this exercise, you may find that you prefer to create your violets with magenta and that this spectrum of colors feels more vibrant.

## COLOR SWATCHES

After your color wheels are completed, I recommend taking some time to create color swatches. Not only is this therapeutic, but it's also an important step in understanding what your paint can actually do. In the chart below, you'll see I mixed quite a few examples and then gradually lightened the value of each color with titanium white across Remember, it's completely about using what you have and knowing what colors give you certain results. Have fun with it and share your findings! You can share on Instagram with the hashtag #painttoprosperbook or tag me @amirarahimart.

Here were the colors used from row to row:

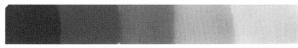

Cadmium yellow + white; continued across

Cadmium red + yellow; after orange, titanium white two times across

Cadmium red + titanium white; continued across

Quinacridone magenta + titanium white; continued across

Prussian blue + titanium white; continued across

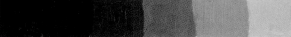

Magenta + Transparent viridian green. After a deep purple was achieved; I gradually added titanium white

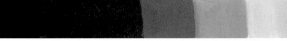

Phthalo blue; phthalo blue + orange, more orange, then titanium white across

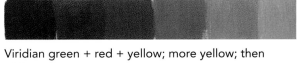

Prussian blue; Prussian blue + phthalo; then white across

Viridian green + red + yellow; more yellow; then white across

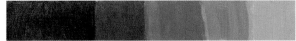

In the final row, I decided to make some more neutral purples and blues with the leftover colors on my palette.

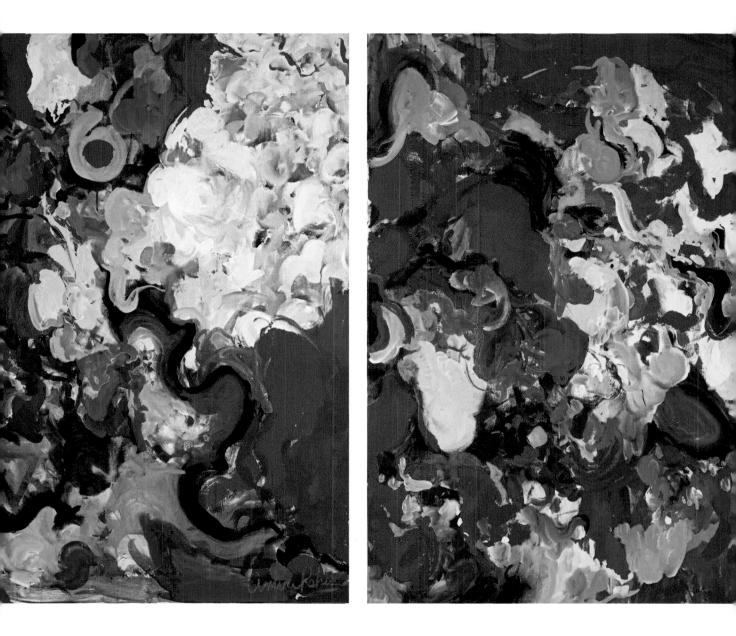

*Worth Waiting For*, 2022, acrylic on canvas, 30 × 48 inches

# WORKSHOP 5

## Go from Amateur to Pro by Mastering Values

This workshop is a game changer because distinguishing values is not only essential to traditional painting, it's just as important in abstract art, too! Understanding this is going to be the first step in creating what I call "mobile-friendly abstract paintings—works that stand out on when viewed on any kind of digital device—and I'm surprised that I didn't learn this in a more direct way in my college art classes. I've been an art class geek for most of my childhood and young adulthood, too, but the classes I took did not break values down simply. Learning values as a foundational assignment is key in any traditional painting class. But when I realized that this could be applied just as well to abstract art, everything changed.

I began to notice that one of the biggest mistakes a young artist can make is playing it too safe in the color spectrum, so to speak. I can still hear teachers reminding me and my classmates to "keep your darks dark" and often circling back to tell us to add yet another layer of depth for contrast. But when it comes to abstract art, it's kind of assumed that color is just a free-for-all. And yet the difference between your paintings looking extremely bland versus exciting can often come down to one simple thing: the powerful use of contrast—specifically, contrasting values. This is because our eyes see values before they see color. Mastering values will elevate your work and give it that professional appearance.

### WHAT IS VALUE?

Value is the difference between lights and darks in a painting. Science shows that our eyes see values before they see color. This is so fascinating because when people see my work, one of the most common responses is, "*I love your colors!*" But what they don't realize is that the reason they're even stopping to enjoy the color is because the values are contrasting *enough*—the composition has such a display of values that the viewer is inspired to look deeper. In other words, we use value to draw people in.

Ultimately, a color is only a color based on the colors next to it. It's subjective and subject to change. Remember that meme that was going around a few years ago, asking people if they saw a white-and-gold dress or a blue-and-black one? The lines were blurred because of how similar the values were to the human eye.

The artist's job is to have **dark** darks and **light** lights, not to stay in the gray zone. And when you combine two opposite ends of the polarity, you create contrast. In other words, it becomes a focal point. As we explore composition further, we'll

talk about focal points. But, for now, all you need to understand is that **contrast** is a great way to pull viewers into your work for the long haul.

## Tonal Value Chart

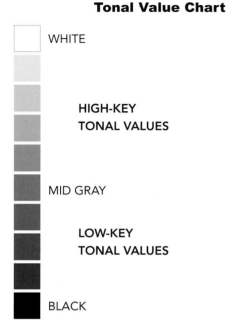

WHITE

**HIGH-KEY TONAL VALUES**

MID GRAY

**LOW-KEY TONAL VALUES**

BLACK

This is a value scale, also known as a gray scale. You can buy premade value scales online, or you can create one yourself.

While a value scale may not be the sexiest art tool, it may be one of the most useful. Number 1 here is black, a completely dark value. As we learned in elementary school, black absorbs light. It is a sum of all colors coming together, forming a black hole. Your eyes are naturally going to go to the darkest area of an image first.

As we go to the opposite end of the value scale, to number 10, we see that the lightest value is white. Now, white is not on the color wheel, but I've layered hints of white over yellow areas in my paintings.

Why? Because while yellow is a slightly lower value than white, it's still lighter than all the other colors. In other words, if you want to make a strong contrast, yellow can be perceived as a white at first "value"—glance—or mixed into white for a warmer effect.

Colors correspond to values on this same scale. For example, deep purple has a pretty dark value, so it might fall somewhere around 2 or 3 on the scale. Orange might be somewhere around 5 or 6, and yellow is probably 6 or 7. Your eyes will become more and more familiar with colors and how they correspond to values the more you paint, and this will help you create really dynamic paintings with powerful contrast.

Artists can avoid falling into the trap of their paintings looking "amateurish" by moving past the few values of gray in the middle. Look at the image of the value scale shown at left: I want your eyes to go to numbers 3, 4, 5, and 6. Cover 7, 8, and 9 with your right hand. Use your left hand to cover 1 and 0. Now you see the values in the middle. Let's call that the "gray area." Most amateur artists tend to stay in this gray area, so you want to avoid this. (I'll show you throughout this section how to check your values quickly and in different ways.)

Now put your hand in the middle of the value scale and cover up 3, 4, 5, and 6; you're left with the two extremes on either side. You want to make sure that your painting has that type of effect—the darks are super dark and the lights are super light, and then there is some use of the middle values to balance it all out and bring it home. But you don't want to have a situation where your painting is entirely "gray" or muted, because this is very boring to the eye.

> **As I became a more skilled artist and a devoted abstract painter, I quickly began to notice what bad paintings look like and I'm sure you will, too. I know the word *amateur* rubs a lot of people the wrong way. But I was an amateur and I'm still an amateur in a lot of ways. So I'm not using *amateur* here as an insult. I'm referring to a clear distinction between amateur work and work that's going to sell—work that's going to make someone stop and stare, instead of moving on.**

## THE VALUES OF COLORS

Let's look at values further in terms of colors. On the opposite page is a helpful graphic. On the far left, we see the gray scale—the value scale just going from white all the way to black. And then for every color, it shows what happens when you add white or black to the color. So if you mix a little bit of black into the yellow, it's going to go further and further down the value scale as it gets darker. If you mix white into the color, it's going to get lighter and lighter and lighter. In this way, you can have one color with multiple values.

However, some colors are going to fall naturally into a certain area on the value chart. Look at the yellow column on this chart. See the boxed yellow square? Note that in the orange value scale, the boxed square is slightly lower than on yellow, and in the red value scale, it is even lower. For violet, the bracket is toward the bottom. What this is indicating is each color's truest chroma, or truest hue. So pure red with nothing mixed into it falls somewhere in the gray middle of the value chart. Yellow is pretty high on the value chart, so anytime you add yellow to a painting, it's going to instantly add a lighter value. Anytime you add pure blue, it's going to instantly add a darker value. The same thing with the emerald green and teal in the chart; you can see that they are pretty low (dark) on the value chart.

Think about the values that you add to a painting with your colors.

# COLOR VALUE SCALE CHART

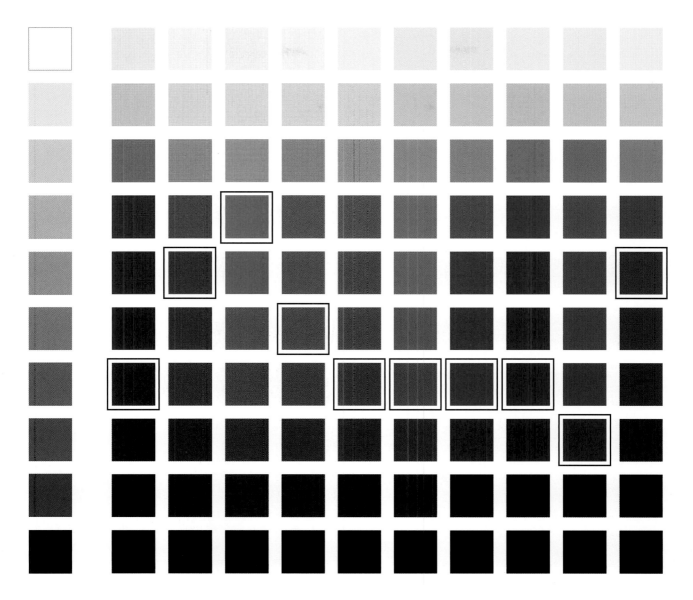

This color-value chart demonstrates the lightest and darkest values of basic colors, as well as each color's truest chroma, or hue, outlined in black.

## EXAMPLES OF VALUES IN ARTWORK

The biggest way that I create colorful vibrant paintings is by using the darkest value of a color instead of using black.

I rarely use black in my paintings; maybe it has something to do with how I learned about the color wheel. Back when I was an oil painter, I had multiple teachers who did not let us use black out of a tube. They told us to always mix our own blacks, and I think my brain just developed the habit of using *color* to create my darkest value in a painting. And boy is it hard to mix your own black! Sometimes, it would take a good twenty minutes, painstakingly mixing and fine-tuning until there was *no* evidence of a hue being present. I later borrowed this same practice when I decided to go pro and become an abstract painter.

In the middle of this chart is carbon black. Directly to the right of the black is pure Prussian blue, and to its left, pure dioxazine purple. At first glance, all three appear to be the same exact value. I can move much more quickly through the color wheel by starting off with one of these colors, as opposed to pure black.

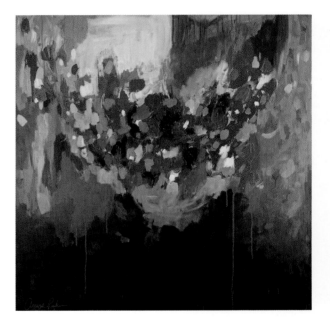

*Bora, Bora*, 2015, acrylic on canvas, 36 × 36 inches. The bottom area of the composition here is read by the viewer as being black, although it is a mix of colors. I remember creating this painting in Abu Dhabi, UAE. The foundational colors remain on my palette today: acrylics in Prussian blue, quinacridone magenta, and dioxazine purple; and turquoise acrylic inks. The rich bottom colors absorb all the light and grab the viewer's attention.

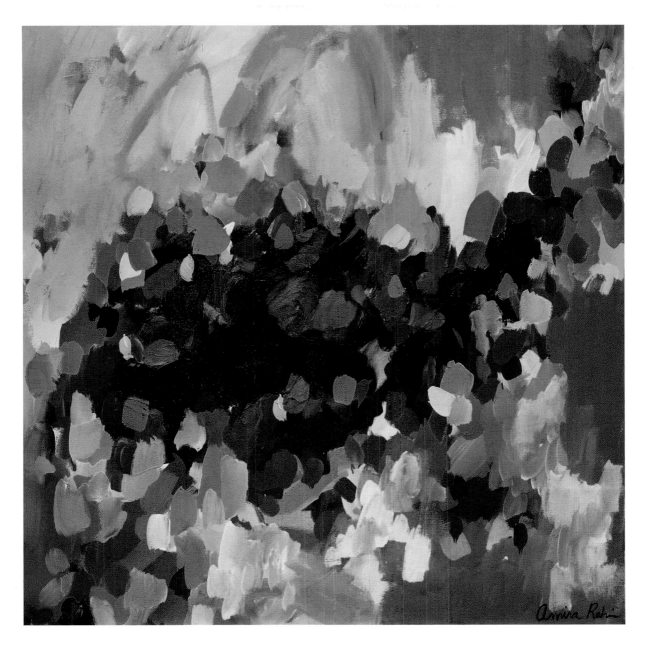

*Identity*, 2017, acrylic on canvas, 30 × 30 inches.
In this painting I used a very dark dioxazine purple
in the center, which draws the viewer's eye to that
section of the canvas. This painting sold quickly
after I posted it, and that's because it was so
contrasting and vibrant, and had that element
of texture in the middle.

Keep in mind that when people look at your work, they might not understand why they're drawn to it or why they feel so moved by it. And that's okay. It's not their job to understand, but it's your job as the artist to understand what's happening in your paintings. At least most of the time!

Am I drilling this point to death?

I hope so, because there's nothing more obvious in a skilled painter's work than their ability to distinctively move across the value scale with ease. And when they don't, well . . .

Let's take a look at what could be considered examples of "amateur work"—a study that I just painted—from a value perspective. (Note: See more about studies on page 50.) The study here, below left, is in color, and below right is the same painting desaturated into gray scale. By repeating a grayscale version of the study, we're able to easily see the use of values.

Many times, when you are new to painting, it is hard to distinguish values. Especially when you're knee-deep in the chaos of an abstract work. However, this, too, will become easier with time. Another good option is the old "Blur your eyes and squint" trick. But again, you may find working with technology faster and more fluid for your practice.

In this study, there is definitely a difference in values, but most of the colors fall toward the lower end of the value scale. It would be a more effective painting if I had punched up the value contrast a little bit.

Here is the same study in grayscale. Even though it is "colorful," with red, green, and blue—even hints of purple—it would fail our values test.

**Pro Tip:** A quick way to check the values in your painting at a particular moment is to pull out your smartphone, snap a photo, and then convert it to the "mono" setting or grayscale option.

At the bottom of this page is another study and its grayscale version. You may look at the image on the left and think it is colorful. What's wrong with this painting, Amira? You're being obnoxious! Well, to be fair, I painted it for the purposes of illustrating a point so I can rightfully bash it.

Yes, it has some yellow, blue, and green—even a hint of orange in there. No doubt, it's considered "colorful." But let's imagine that I was posting it on Instagram, where a vast majority of artists are selling their work now and vying for the attention of impulse buyers.

Once we shrink this study down to the actual size of a post in an Instagram gallery, which is a grid with less than an inch of display space for each image, you can see how this painting would quickly be glossed over.

If you were showing your paintings in a museum on large-scale white walls with dramatic lighting, people would likely stop to look. But since most painters don't have that luxury, create elements of contrast so your paintings pop even at the size of a thumbnail.

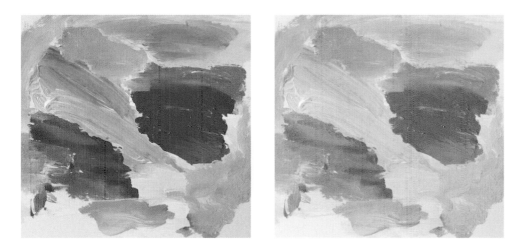

Here is the same value study at the size of an image in an Instagram gallery.

Let's analyze the values in this value study. When you look at the desaturated, grayscale version on the right, you see that, other than the stroke of purple-magenta in the middle, most of the painting falls into the gray zone of the value scale.

## CREATING CONTRAST/TENSION

There are several ways to create contrast or what I like to call "tension" in a painting.

- Throw in some white values next to dark values and a mix of both throughout.

- Create contrast with a neutral background (beiges, taupes, or grays) and a cluster of saturated colors. Or use neutrals around an area where there's a nice pop of pink, orange, or yellow. It's powerful to have all that saturation next to a neutral, faded, or grayed-out area. We'll be diving into how to use neutrals in abstraction in the next chapter.

- You can create contrast by using colors from the opposite sides of the color wheel—the complementary colors (see page 33)—to create a focal point, but try to avoid clichéd or common combinations. You can create a stark contrast by putting yellow next to purple or red next to green. However, you can use a lighter version of one of those colors and it will still have the same effect. For example, I could put red next to green and bring Christmas to mind, or I could put pink next to green. Red and pink are technically the same "color"—the same hue, just a different value. That's why green and pink together are a more nuanced contrast, while red and green can be rather obvious and overt. Likewise, instead of using a bright yellow next to a rich purple (which makes me think of the super-contrasting Los

**EXERCISE**
## Evaluating Value

A fun and crucial step to deciphering your work is being able to perceive value. In the beginning, you will find that you may need to use tools, such as turning your camera phone to the grayscale setting, or using a value finder (a grayscale card with key-holes that you can place over colors to help determine value). But, eventually, it will become second nature.

1. Select three paintings that you've completed in the past year. List all the ways that you achieved (or didn't achieve) contrasting elements, especially values, in each of them.

2. Next, find three paintings from living or deceased artists that you love. I recommend poring through some art books or even taking a look at some of your favorite abstract artists online. Notice the range of values in the works. Evaluate these paintings according to the criteria that we just covered in this section.

Angeles Lakers uniforms), I could use a nice bright yellow next to a saturated lavender. Even though lavender has a lighter value than rich purple, it's still going to create a contrast next to the yellow. ■

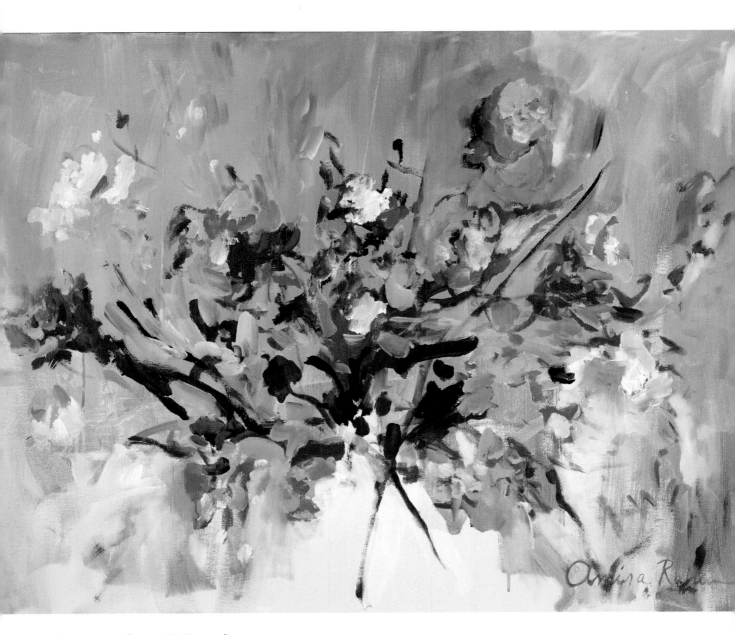

*Courage to Bloom*, 2018, acrylic on paper, 20 × 24 inches. I painted this piece for a demo during an in-person workshop as we worked through neutrals. I was very pleased with how every color was able to vibrate in harmony and each was set off against the grayed-down blue tones in the background.

# WORKSHOP 6

## How to Mix and Use Neutrals in Your Work

When you're new at painting, especially abstract art, you can end up mixing mud. Remember how I mentioned mixing my own black in classes as a teenager? Often I would end up with just a muddy flat color that felt like a waste of paint!

In this workshop, you will learn how to make your colors pop with neutrals, instead of drowning in the dreaded gray zone with lots of mud.

You may think that neutrals are boring or ugly, but they can be beautiful and they can allow your boldest, brightest colors to shine. Witnessing the miracle of a rainbow after a storm feels so satisfying, not only because we see every single hue at once in perfect order, but because it outshines the dark stormy clouds behind it.

What I love about this lesson is that it saves you money on buying art supplies. Quite literally, you can learn to work and harmonize six to seven main colors, instead of spending hundreds of dollars on manufactured neutrals that would look more vibrant if you mixed them on your own.

So let's dive in.

**Black**

First, I mixed black. Now this isn't necessary, but I want you to at least try it. You make black by mixing the three primary colors—red, blue, and yellow—together (in theory). You could also try with other colors you have on hand; feel free to improvise until you get as close to black as you can. Harder than it looks, isn't it?

**Orange + Blue**

Now, we can move on to neutral mixing. Anytime you want to "neutralize" or desaturate a color, you mix in its opposite or complementary color (see color wheels on page 33). To recap, orange is the opposite of blue (think New York Mets uniforms). Red is the opposite of green (think Christmas), and yellow is the opposite of purple (again, Lakers).

Here is how you make this first swatch series (on the bottom right of page 46), going from left to right. First, we mix a bit of blue into orange. Not so much that it overpowers the color completely, but enough to let us know it's no longer a clear orange. Notice how it gives us a mahogany sort of color. You can add a bit more orange and see how it brightens that tone even more. Now with a touch more blue, we have this sort of neutral green-gray color. The next step is to add titanium white to each of the colors you mixed. Now we have two beautiful neutral colors! One with a touch of blue, another as a creamy, grayed-down orange.

## Red + Green

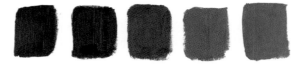

Follow the exact same steps as above, mixing green into red. The green takes the red all the way down in saturation. You can see here that we have some nice brown, almost skin tones in the middle, by adding yellow. Tinkering with color combinations of cadmium red and green and white, you can also yield results that are purple.

## Purple + Yellow

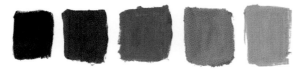

For the second swatch series, start by mixing a small amount of yellow into purple. Because purple is such a heavily tinted color, you can see how it completely consumes the yellow. But at least we have lost some of its intense saturation. Now by adding a bit of titanium white and more yellow, we can see a clearer neutral starting to form. Adding even more purple and white, we get a mauve color. The last two options are completely up to you. But, here, I decided to push the yellows further and make some light, warmer neutrals.

## Freestyle Using Your Remaining Paint

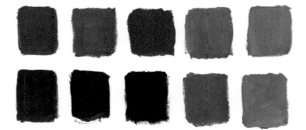

Continue mixing and matching neutrals with the colors on your palette. There truly is no limit to what you can find! Here are some examples of my neutrals after more mixing. These colors would make great backgrounds for the most saturated color to sit on top. Often artists don't know what to do with the "whites of a canvas" showing when painting. My advice: Stick some neutrals in there! Make it more vibrant and give your viewer some subtle surprises to really make your composition feel unique and fully developed.

# Neutrals: Full Study

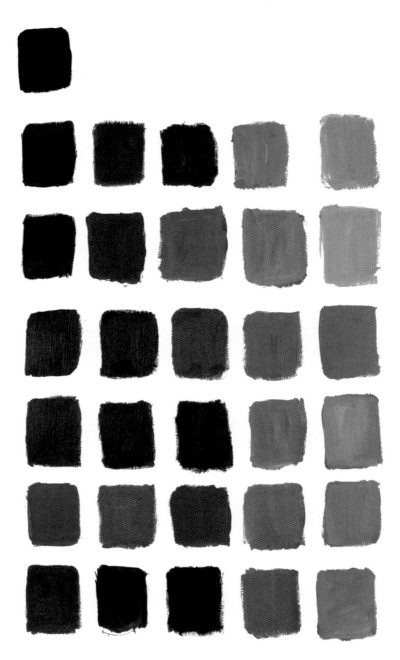

Here is my full collection of neutrals on mixed-media paper.

Creating neutrals using the colors that are *already on your palette* and in your painting will allow you to create more cohesive color harmony while maintaining sharp value contrast.

So set yourself free to play and experiment with all the colors on YOUR palette. Make swatches of these beautiful neutrals you've created!

1. Start to mix your own range of neutrals on a color swatch pad.

2. Hang it up in your studio for inspiration.

3. Find other artists doing the same assignment by sharing it on Instagram, with the hashtag #painttoprosperbook or tag me at @amirarahimart so I can repost!

Remember, my teaching style is not about memorizing a hundred different formulas to mix a color. You want to get into that FLOW state and stay in there as long as possible, not stop to flip open a book to tell you the exact ratios for making a specific color. It's not about perfection here. It's about instinct and expression.

Next we'll talk about how to use neutrals to build up your composition and to increase the vibrancy or contrast of your artwork. ■

# WORKSHOP 7

## Deeper Color Harmony

As we dive deeper into the painting process, I find limiting yourself to a monochromatic color scheme to be a great way to start to develop a *visceral* connection to color. Let's make it happen. We will be using studies—preliminary planning or practice pieces—as a way to complete the following exercises. I recommend starting out your painting practice—whether you are a beginner or a veteran jumping back in—by making your own studies in each of the colorways shown in the examples I created on pages 52–58.

Some things to keep in mind when painting with acrylics: Acrylic paint gets darker and duller as it dries. So if you return to any of your studies the next day and the colors just don't feel as vibrant, keep going. That's just the nature of working with acrylics. For this reason, I encourage you to use multiple layers, and keep layering. And if you truly love painting, which I'm assuming you do, then you will enjoy returning to a painting to make it even better than when you last saw it. ■

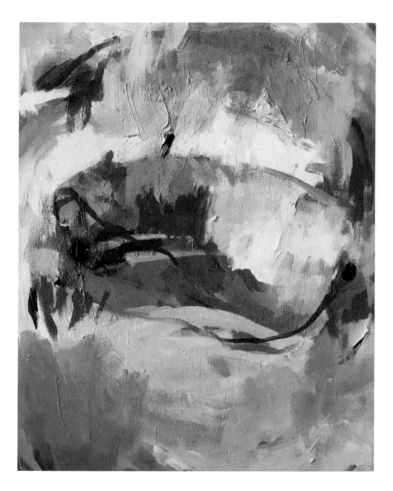

"Studies" are short bursts of paintings not designed to be sold (although some artists do sell them). They are created solely for the purposes of practice and exploration.

"A monochromatic color scheme can be a great way to connect to color. It's okay if you feel the urge to add another colorway into the piece. Each color can be a jumping-off point for a whole painting or even a series! But if it's just a study, remember that that's fine, too. "

# PURPLE

Purple, or violet, is a combination of both cool blue and warm red. It was frequently worn by royalty as a signal of their status, and is overall a magical, mysterious color to play with.

**1.** I start off my purple color study on mixed-media paper, using thick broad strokes and a flat brush.

**4.** Now taking a smaller brush, I start to mix in more white. This is just a study, so I can have fun with this. I'm not even thinking about composition—just exploring movement and playing with values.

**2.** Next, I add some magenta to the top, and some strokes of dioxazine purple at the bottom. Notice how the magenta is transparent enough to still let the purple strokes show underneath, but strongly pigmented enough to warm up the piece.

**5.** As you create your purple study, you may find yourself naturally wanting to include other colors that are next to purple on the color wheel. I add white to the magenta and push the envelope a bit more into pink. It is no longer monochromatic, even though purple is still the *dominant* color. You can see the subtle transitions from blues to magenta and purples.

**3.** I add some Prussian blue to the mix. I decide to contrast the warm translucent magenta space with some opaque blue. (Remember: Adding titanium white to a color not only changes the value, but also makes it more opaque.) The blue is continued into the bottom with some subtle blue-violet tones. I mix more titanium white into the middle, getting some lighter values in through lavender.

**6.** Finally, ever the rule-breaker, I decide to add a pop of yellow on top of the magenta. Just to see "what would happen." I like how the yellow trails off in the far-right corner. You can also start to experiment with mark-making as you see here—little dashes and dots with your brush.

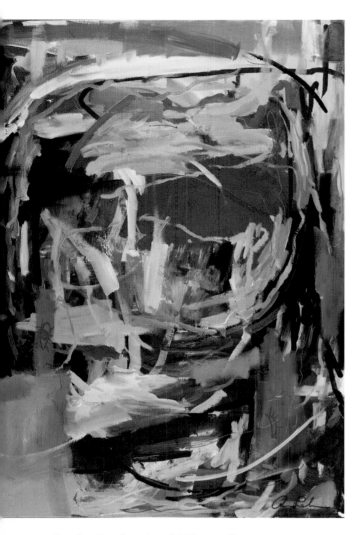

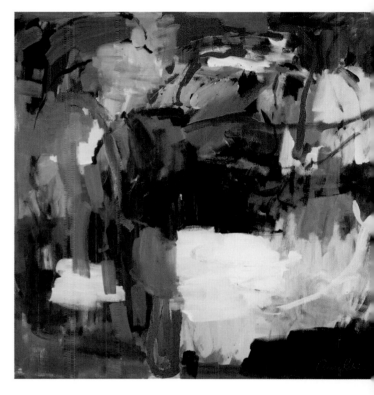

*On the Road to Joy*, 2018, acrylic on canvas, 40 × 30 inches. I am almost fighting to keep the purple dominant here. My painting spirit wanted to see what would happen if I added yellow, green, and blue—and this is what happened. Notice your own color intuition, and don't fight it when it shows up. Honor it!

*Grace*, 2018, acrylic on canvas, 36 x 36 inches. Here's another example of me wrestling with purple. You can see a more neutral, almost moody use of purple in this painting.

# RED/MAGENTA

The intensity of red is undeniable. Historically, paintings that contain red have been more highly valued over the years, and even today it is still believed that if you want to increase the chances of getting a painting sold, you should be sure it includes the color red. Red charges us, calls us to step into our power, and also activates the root chakra, located at the base of the spine, which is thought to be associated with stability and life force.

**1.** For the start of this study I decide to grab my cadmium red and "draw" with it straight out of the tube. You can activate your canvas with many things—pencil, light brushwork, or a foreground. But sometimes it's fun to use the tube like a marker, too!

**2.** Next, I make a big red heart over the loose marks.

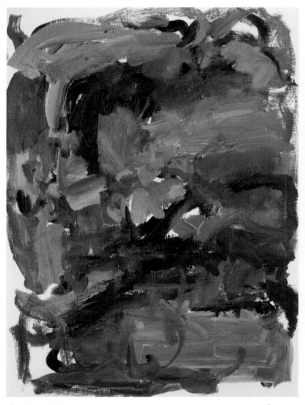

**3.** Then I take a small filbert brush and start to mix in some white. I am just covering the page with whimsical strokes—loosening up and letting the color work its magic.

**4.** Now I incorporate some warmer magenta and violet tones around the painting, as well as more white. It is definitely an opaque study and there's not much I can do with it at this point. I add a touch of pale yellow and titanium white for interest.

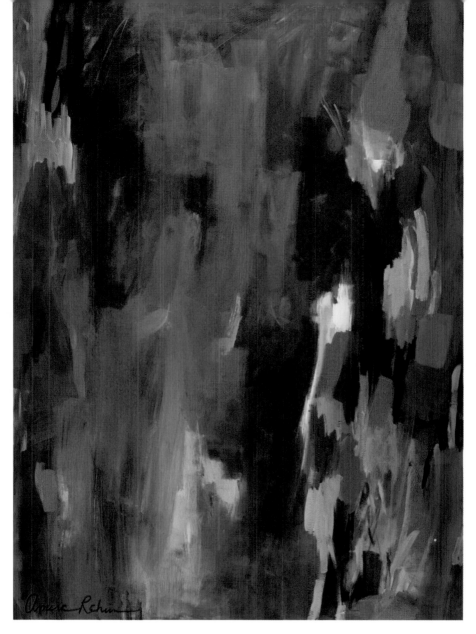

*Mrs. President*, 2016, acrylic on canvas,
30 × 40 inches. Even though this piece is
relatively simple in composition, it took me days
to really get it to where I liked. I used glazing
medium with a hint of white in much of the middle
left portion. You can see how it creates this pink
glow over the painting, while still letting the deep
tones of magenta pull you in. I chose neutral blue
violets and oranges to complement the dominant
color of this piece.

# BLUE

The steady comfort of blue energy is profound. We are transformed by the sight of clear blue skies, or crystalline ocean waters. Blue can be used to express deep sadness and longing, but it can also convey serenity and expansiveness. Tap into the versatility of this color and escape your limits.

**1.** Using a round brush loaded with water, I start moving Prussian blue paint around the surface almost instinctively, leaving watercolor-like wet areas on the page.

**2.** I flip the paper upside down and immediately start working in some dioxazine purple. It lends itself nicely to the blue because blue and purple are next to each other on the color wheel and in the same color family. My strokes are unpredictable and without much thought. I recommend making expressive, active, confident marks and lines with your paintbrush throughout. Many beginners like to hold the brush low (closer to the bristles) and paint like they're icing a cake. Instead, hold the brush further up the handle to keep your marks loose, and keep the brush moving dynamically.

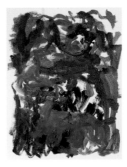

**3.** Next, I decide to work in some neutral tones—greens and browns. I also freshen up my dark values, resetting the study with some more Prussian blue so that we don't lose the depth.

**4.** I opt to simplify the study by rapidly filling in the page with broad, sweeping, horizontal strokes, covering what's underneath. You can see a phthalo blue form at the top, a slightly more violet opaque shape underneath, and a slate-gray smaller shape to the right. I keep the wild neutral green strokes around the page there.

**5.** I flip the paper one more time and decide to finish the piece off with a bit more neutral green. I mix more titanium white into the middle. Notice how we still have the translucent purple and Prussian blue strokes that started the painting peeking through.

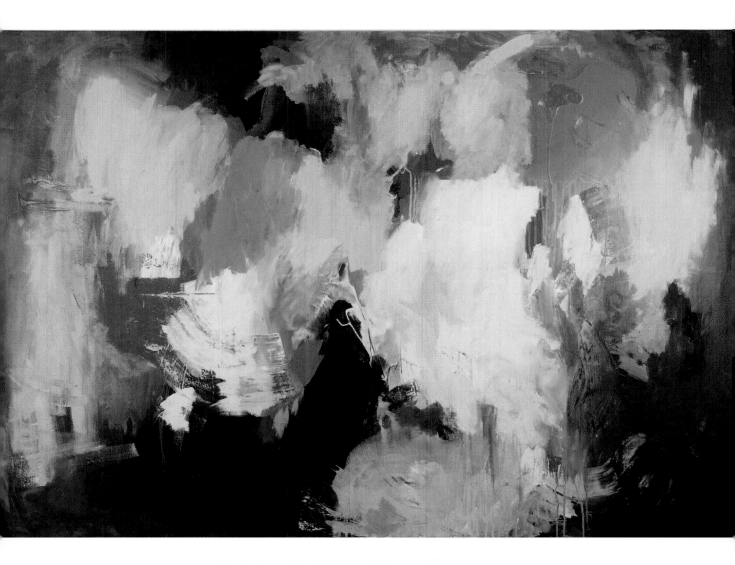

*She Ordered the Sashimi*, 2016, acrylic on canvas, 60 × 40 inches. Blue remains a foundational component in the majority of my work. As Picasso went through his famous "Blue Period," I've gone through my own. The work above, for example, reflects my subconscious during a time of isolation and the grieving of a life partner. The dark depths in those times, echoing across a canvas nearly 6 feet wide provided the vast space I needed to confront my own healing. Forever, we are a work in progress.

# GREEN

Green is the most healing color to the human eye. Green is instantly associated with healthy nature—cool grass, lush forests, and trees. The most primitive parts of our brain equate green with abundance, life, and success. In healing, green is a powerful "alchemizer" and healer of the heart chakra, which is associated with love, peace, and harmony. Find love in these hues.

**1.** For this study, I decide to go with a play on stripes, freeing my mind from any need to nail a composition. I use a cool transparent viridian turquoise to start, and then follow that up with viridian green and premixed phthalo blue + cadmium yellow medium.

**2.** I use a flat brush to add a summery yellow-green center stripe. Then I layer on Prussian blue to ground the energy a bit deeper.

**3.** After blending in a bit of white into my Prussian blue section, I smudge out most of the surrounding perimeter. This breaks up the predictability of the vertical-stripe motions, and creates some tension. Using orange-yellow acrylic ink, I place a few drops onto my study.

**4.** I mix a bit more white and allow myself to break up the composition further. Notice any resistance you may feel to "ruining it." If you find yourself wanting to add other colors outside of the green chroma, accept those inner nudges and do it. It could be an insight into your inherent color sense and style.

**5.** I fan out much of the first layers with different shades of green. This is quite easy because I already have the colors on my palette. Lightly, using some white, I create more values and push the color tones a bit further. The study stops here. While still green overall, notice how the yellow space looks almost golden against the other colors.

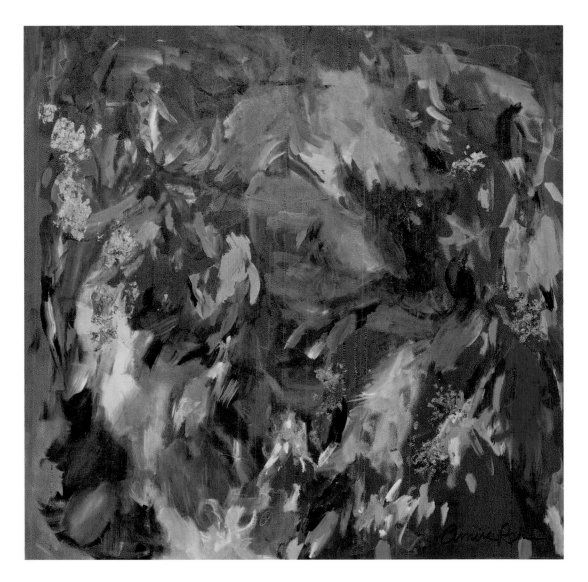

*The House That Love Built*, 2020, acrylic on canvas, 36 × 36 inches. This painting was definitely a totem of my own will in the moment. A number of years ago, I decided that the idea of "home" is ultimately a social construct. By 2020, I was ready to invite a new level of trust with my intuition or Higher Self. *The House That Love Built* is the victorious moment of me finding home within myself, no matter where I am in the wide, green world.

## A Word on Making Bad Paintings

If you're feeling afraid to make drastic changes to a painting, I need you to know that you have to be willing to destroy your paintings!

I often tell my students in workshops, "That looks good, now ruin it." I have had students then report back that a painting they "ruined" had quickly sold.

If you are unwilling to destroy a work to make it into a better painting, you'll be stuck where you are. How many more paintings are you going to make in your lifetime? Hopefully, a lot. The painting you are working on now and are scared of "messing up" is not going to be your last painting—you have many painting opportunities ahead. And even when you paint over something, that painting has taught you lessons every step of the way. So it's still part of the process.

## MAKING COLOR SELECTIONS

When I'm deciding what color to add next to another color, I use my color wheel to look for related colors (colors closest to a given color on the wheel; see page 33). However, I move away from pure primary colors and instead look at all the different shades, tints, and tones that can be created from a given color.

For example, if I want to put a color next to yellow, I could consider a pale yellow-green or a pale yellow-orange, or a dull yellow-green or a dull yellow-orange. Any of those tints would work well because they're related to yellow. A color that is slightly grayer or lighter than a saturated color makes it more interesting.

If you're finding that the colors you're mixing aren't coming out as vibrant as you would like, it may have something to do with an opposite color (a complementary color on the color wheel) sneaking into the mix, making your colors muddy. The more you mix colors, the more intuitive the process will become.

### Colors Change Depending on Context

A color's hue is not as important as its relationship to the colors next to it as well as everything else that's happening in that painting. I once heard an explanation of the science of color that said that we don't see any one color in isolation—it's all about seeing colors in relation to other colors. In other words, there's no one size fits all to your paintings. You need to respond to the colors in front of you and learn to dance with that information. So you can start off with a color scheme in mind, but remember to allow it to morph and adapt. ■

**"You have to get the bad paintings out of the way before you can get to the good ones. So if you spend months making work you're not impressed with, that's actually great."**

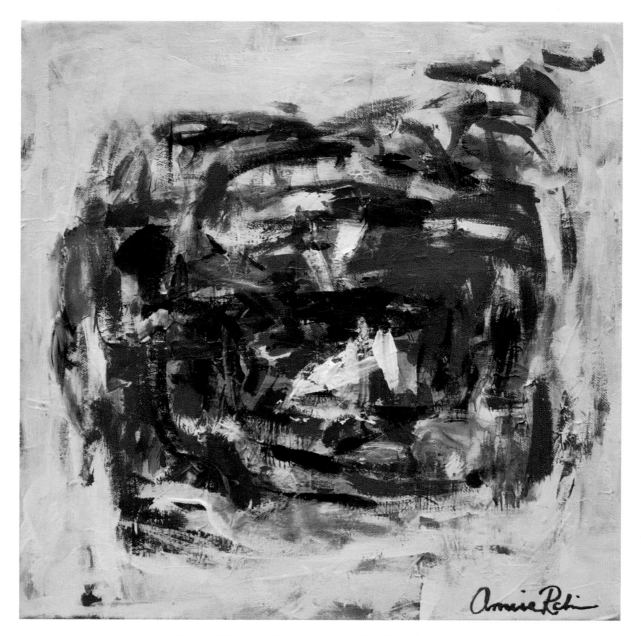

*Kissed*, 2016, acrylic on canvas, 12 × 12 inches.
The darkest value here is magenta, and yet it has
achieved a full range of values. I would say that if
you choose magenta for your darkest value, then
you should be sure to take the other colors to a
high-value extreme. In this painting, I wanted to
explore the relationship with high-key pink and low-
key neutral, grayish off-white as the foreground.

# Color Bridges and "Lifting"

If you find yourself creating work that lacks cohesion or something about the colors isn't working, you may need to build some bridges. If you use too many colors in a painting and you're bouncing across the color wheel, the color scheme may end up jarring and not working. Here's what I mean:

If you're using magenta or red in a painting and you decide to also add green, it can look garish and Christmasy. These colors are complementary, meaning there is lots of contrast—so you need to build a bridge between these two opposite colors by using some or all of these techniques:

- Lifting areas of one or both of the colors so they are lighter, pastel versions of the color.

- Neutralizing areas of one or both of the colors by mixing in a touch of the opposite color (for instance, add a speck of magenta or red to your green to neutralize it).

- Add a color or colors between the two opposite colors to include more of the color wheel and lessen the contrast between the two complementary colors. For example, add some blue or yellow to a red/green painting. You are making the green more at home in the painting, since yellow (or blue) helps to create green.

Take a painting that you're struggling with and look at it from this perspective. Try some or all of these methods to create bridges between your colors and make the painting more harmonious.

If you struggle with this, try painting with a more limited number of colors. I usually only use five colors. Try using nothing but a few cool hues, like blue and blue-green. Use a combination of lightened (with white), saturated, and neutralized versions of these colors. Then to add pop, choose a color that's further away on the color wheel from blue or green, such as magenta. Don't layer on too much: Use a sparing amount of it to create interest. If it's too much contrast, lighten it or neutralize it a little with a dab of green.

The more you practice this, the more comfortable you'll get with it and the more confidence you'll have to play with your color palette.

# WORKSHOP 8

## How to Source Color Schemes

As you begin to dive into a flow here, you may find yourself hungry for color-scheme inspiration. Art is often used for commercial purposes—from stationery to textiles to tableware—and in interior design. These fields all have trend reports and "Color of the Year" announcements that abstract artists can track. In addition to these, there are many different ways you can find color schemes to base your paintings on.

- One of the most obvious ways to source amazing color schemes for paintings is interior design magazines. I love to browse through *Architectural Digest*, *Elle Decor*, and other shelter magazines to see fresh new art. It also gives you a sense of what designers and curators are selecting for home decor. Since most of us want our art to hang in someone's home, it's worth the exploration.

- Television shows are surprisingly helpful in sourcing color schemes, but not in the way you would think. Sometimes you will see glimpses of an entire scene that makes you want to hit pause because you've gleaned some inspiration. There's a lot that goes into TV production: lighting, color, camerawork. Why not make use of your time in front of the screen to discover new ways of matching colors. Even more so, you can see beautiful paintings on the sets of many shows. I remember having to pause a few times watching *Modern Family*, for example, because the art used on the show was so bright and cheerful. I couldn't have imagined years later that my art would be used on the sets of commercials, TV shows, and movies as well—making this point super meta for me.

- When all else fails, nature is, of course, a great teacher. Flowers in a neighbor's garden, traveling to a new country, or even a trip to your local aquarium may spark your courage to use color in a whole new way.

- Try gathering color schemes on Pinterest by searching the terms color schemes, color palette, colorways, and art.

When it comes to color, know that our personal vibrations also come into play. We resonate at a certain vibration, and that resonance changes constantly. One of the cool things about being an artist is that it gives us the opportunity to be a little

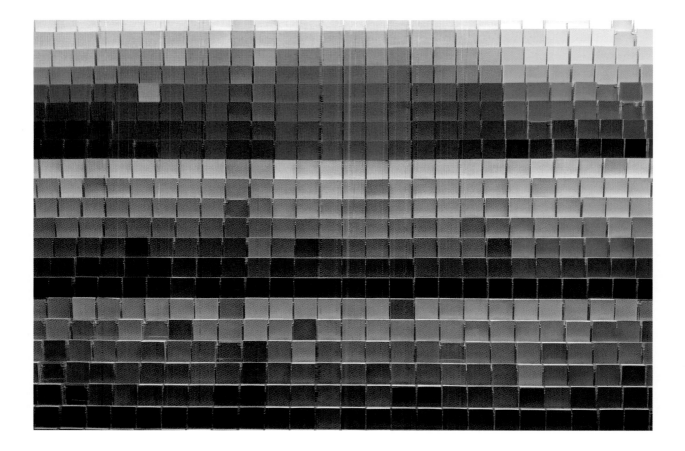

bit more self-aware and reflective, more introspective, and more empathic. Art can become a tool for your own healing, specifically by bringing out the colors that you are vibrating with.

How are you going to know what type of energy you are emanating or what type of colors you're attracted to, if you don't set an intention to find out?

I remember when I was a kid, I didn't yet paint regularly but I used to always express myself with my clothes. Every day when I'd go to high school, I'd say to myself something like, Today I'm going to wear a red shirt because I want to tap into my

In the beginning of my abstract art journey, I would also frequent the hardware store and grab color swatches. They are free and a way to mix and match colors. Do any of the above sets of colors speak to you?

power. Other days I wore all orange or all blue or pink or black. I was always a very colorful kind of dresser—my clothes were my canvas.

In the following exercise you'll find five color schemes with intention. They can be used to challenge yourself to paint something that's new and exciting for you—so you don't end up doing the same painting again and again by default.

# Color Harmony

Forget the colors you always go with and let's start completely from scratch and really dive into the essence of who you are on a soul-vibrational level. Once you do that, and you make it a regular practice, you won't need to match other artists' color schemes. I want you to get into the habit of attracting your own color vibrations and being aware of your own color schemes.

1. Find three to five color schemes that you are drawn to re-create in your paintings. You can use reference photos from Pinterest, your own images, or anywhere. As you select your color schemes, make mental notes of the visceral feelings that you feel when you look at whatever colors you choose.

2. Try to describe what is happening in these color schemes. Think about why they work. Put this into words in your journal. What feelings or memories do these colors bring up for you? Do they transport you to an event? A place? Maybe make you think of a food? A song? Think of how you would describe these colors to a five-year-old. Tap into that visceral essence of how the colors make you feel and the memories that they evoke. This is how your brain creates a connection to certain color schemes on a subconscious level.

3. Using your color-mixing skills, practice re-creating these color schemes with paint. You can do color swatches on canvas or acrylic painting paper, but don't worry about it being a finished painting for now. The goal here is not to create a finished painting, and don't feel that you are married to these colors—this is an exploration.

# " Color is a mood. "

## SELECTING YOUR DARKEST VALUE

One question I often get asked by students is this: "Does your darkest value always have to be Prussian blue?" As you know, I love using Prussian blue, dioxazine purple, or even a mix of the two as my darkest value. The logic behind this is quite simple:

**Cool colors recede.**
**Warm colors advance.**

Because I was trained traditionally for years in oils, I found that a lot of what makes a great realistic oil painting can be applied to a work of abstract art. If you take a look at the color wheel and divide it in half, you will see that the cool colors are also the darkest.

As I mentioned in workshop 5, my professors always reminded me to "Keep your darks dark" and to always work from dark to light. There was no room for arguing here—LOL! It was practically oil painting law. Of course, if you're coming from a watercolor background, then you know it is completely opposite. You are painting with the light and negative space first.

Painting with cool or even darker values first can create the perfect foundation for your abstract paintings. But depending on your "color mood" of the day and your preferences, that may be a rule you are willing to break.

For example, what do you do if you want to make a primarily pink painting? Do you have to start with Prussian blue or purple? No. And you should never feel like you "have" to do anything as a painter. Remember: Once you discover your way, all the other things will fall out of the window. And that's my ultimate goal for you. **Be your own guru.**

In the art world, we talk about "high-key" and "low-key" colors. High-key colors lean more toward fluorescent yellow, orange, and other intense, bright colors. And then there are low-key colors, which are more muted. I try to create a balance of the full spectrum of high- and low-key colors in my work; I like my paintings to hit all the values and for the colors to have some really dark moments, really bright moments, and then some moments in between. However, that's not the only way to make great abstract paintings.

There are a lot of paintings where the darkest value is magenta or red. ■

# WORKSHOP 9

## Using Transparent vs. Opaque Paints

One thing that's super important to keep in mind when you are painting is the difference between translucent and opaque paints. This is well-known among classically trained oil painters. In order to "paint" the light in a beautiful landscape or romantic cottage scene, artists had to be keenly aware of how to bend light on canvas. And yet, I didn't see this being talked about enough in abstract painting materials, despite it being a crucial breaking point in my own work.

If you enjoy seeing paintings that practically glow off the surface, then this section is for you.

Let's dive in with a quick demonstration and a practical way for you to remember this.

How do you know if a paint is transparent or opaque? There are two ways: First, most manufacturers of acrylic paint put information on the tube that describes the opacity/transparency of the paint. For example, Golden paints have a "slider" on the back of the tube that shows where the paint falls on the opacity/transparency spectrum. Golden paints also have a swatch of paint on the front of the tube. Beneath this swatch are three black lines. The degree to which you can see the lines indicates how opaque or transparent the paint is.

If you can still see the black lines through the paint, it's a translucent paint. If the black lines are completely covered by the paint, you're holding an opaque paint.

However, some manufacturers represent opacity with a square or scale. This can get confusing. And some do not indicate opacity at all. Go figure!

You should test the colors you have in your arsenal and organize your tubes by transparency to opacity.

Anytime you add white to a color, it not only dulls down its vibrancy, but it can make the color irreversibly opaque.

Why is this important? Well, transparent colors get along together. They mix well. And they ultimately help you establish layers and depth to your paintings early on. They can easily be mixed into other colors without muddying them up. They also let light in, allowing the viewer to go deeper into the painting.

Opaque colors are the complete opposite. They can almost act as stop signs in a painting. They don't let light penetrate through; instead of going deeper, the viewer's eye hits an opaque color that bounces the eye right back off. So be mindful of when you start to add an opaque color into your abstracts. There is no hard-and-fast rule for when or how. It is just something to be aware of as you create. Many times in your

paintings, you will make "mistakes"—"happy little accidents," as the late painter Bob Ross would say. But mistakes still teach you something. I call these paintings "teacher canvases" because you may not be able to sell them, but they taught you an invaluable lesson. ■

Create a thick black line down a page in your sketchbook. Afterward, place each color that you're using across the line. If you can still see the black line, it means that color is transparent.

Here, I decided to add titanium white to each of the colors I used in the drawing to the left, and test it again. You can see that the same colors become more opaque.

## Teacher Canvases

Some canvases are our teachers. They are complete when you can't go any further. And yet, they spark interest for the next canvas. Release these. Share them. Or hang them for reference. Don't block the flow with your teacher canvases. This is why posting my art online is a nonnegotiable on my journey and has always helped me grow. Because I have always posted and will continue to post "teacher canvases." Some good. Some terrible. Some you can even still find on my feeds. But they were the teachers to get me to the next stage.

Recognize when you are looking at a "teacher canvas," which you can set aside without judgment, as opposed to a "breakthrough canvas."

Breakthrough canvases make you skip all the doubts and make you want to sell it to the highest bidder! Because you know you did it. And you love it. No questions about it.

Beginner, amateur, veteran. It does not matter. We all have teacher canvases and we all have our breakthroughs. Just paint anyway.

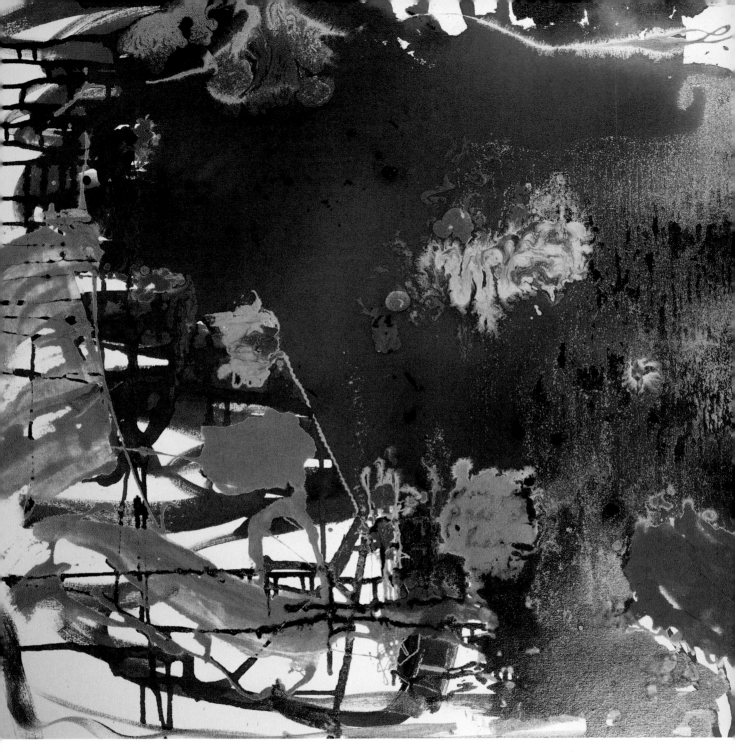

*I Needed a Breakthrough*, 2022, acrylic, ink, enamel, and gold on canvas, 30 × 40 inches

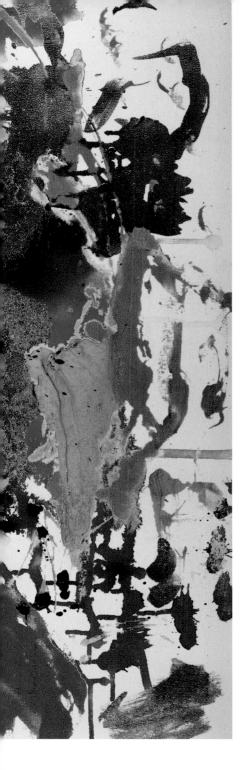

# CHAPTER 3
# COMPOSITION 101

# WORKSHOP 10

## Understanding Composition

Composition is one of my favorite topics to teach—probably because it is the hardest to teach, and I'm always up for a challenge! This topic is huge and deep, so we're going to devote two chapters to it. To be honest, it can also take years of practice to fully understand composition, but that doesn't mean you can't make a great start now.

I remember in art classes that when it came time to discuss composition, more often than not one of my instructors would say something like "You have to develop an eye for it," as if it were this elusive fairy who visited some artists and sprinkled magic dust on their paintings. We would gather around and look at paintings by the likes of Edward Hopper and swoon as he was crowned the Composition God.

I believe that composition is not talked about enough partly because it is a cumulative knowledge—it's something that it takes people years and years to fully understand. And it's much easier to teach someone how to mix the right color or how to get the right shade of pink or green than it is to teach them why their painting doesn't make sense overall. But just because it's not something we can learn and master quickly doesn't mean we should avoid it. I overcame my blocks with composition in abstraction by studying other fields. As it turns out, photography and graphic design have similar elements to painting.

### COMPOSITION IS KING

Composition is defined as the nature of something's ingredients or constituents. It is also defined as the way in which a whole or a mixture is constructed; so when you think of a painting, all of the elements of a painting that make up that whole give you the composition. You can categorize a piece of art in any form (painting, music, literature, etc.) as a composition—a sum of its parts. A painting can literally be reduced down to its composition. It is the most elusive yet the most important element.

When an artist plagiarizes another artist's work, it is usually the composition that they steal. When you think about composition, it really is a process of creation. When you finalize a painting and you're satisfied with that composition, you feel protective of it.

You can think of composition as an architect's blueprint of a house. You can change the colors of a house again and again. But the design is the foundation, the very structure that this house depends on. It all goes back to the blueprints—or, in our case, the composition.

# What Are the Elements of Composition?

Composition requires an artist to arrange (at minimum) these three things in order to achieve a successful painting:

- **Form:** The artist must arrange forms, which in our case will be color shapes (unless you are depicting representational forms). I generally don't paint identifiable objects or faces, so the areas of color are my forms.

- **Line:** The actual marks, or trails of brushwork. Also implied line (see more on page 76).

- **Weight (balance):** How the forms essentially "fall" on the surface, pulling the observer's eye down, up, left, or right on the picture plane.

Let's look at each of these three elements in greater depth.

## FORM

Now brace yourself, it's going to get a bit artsy-fartsy for a minute. Form is simply an object that takes up space, and the object can be 2D or 3D. In our paintings, you can create a 3D effect by understanding value and tone to create shadows and light.

Form can be geometric, but a lot of forms, especially in abstract art, are organic. Such forms can include fluid art, blobs of paint, color fields, and more. Part of what draws us to organic forms is the fact that many of the forms that we see in nature are also organic. This is nice for us as abstract painters, because all we have to do is lean into nature itself to give us confidence.

For this reason, I believe people respond to abstract art on a visceral level. When done effectively, it hits people in their gut. Often people will be drawn to your work without understanding why. **But you need to understand why.** By recognizing our affinity for organic forms and using them in your painting, you're paying homage to nature: to the lack of control, the chaos, the randomness, the serendipity, the spontaneity—all this Divine Intelligence that we see in the world around us when we tune into these elements. This is how our artwork creates an experience for people.

Since abstract art often means there is no recognizable object, the painter must connect with the viewer through the paint itself. In this way, the medium almost becomes the subject. Couple this with texture (which I'll show you how to add on pages 120–22) and you'll have a painting that comes to life. So we're applying paint to achieve these beautiful shapes, emotions, and energies. ■

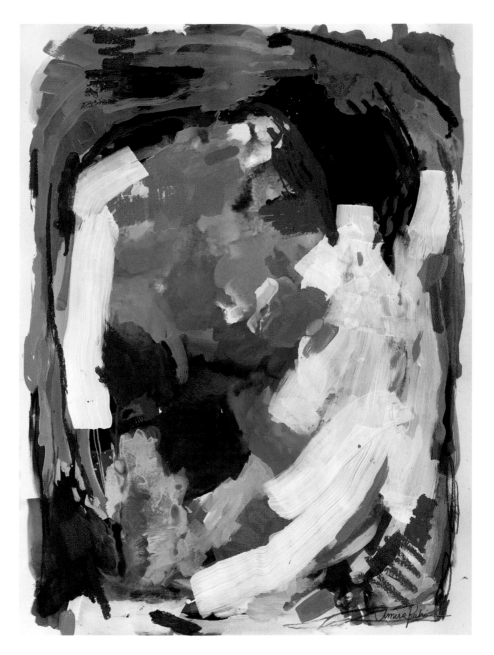

*Ubud 1*, 2018, mixed media on paper,
30 × 22 inches. Creating forms with paint is
something that I've been doing for years intuitively
as an abstract painter. But when I examined it
further, I realized what I'm actually doing is using
color as a shape.

**"Abstract painting is scary. It can be uncomfortable for artists because you have to get comfortable with not knowing what the finished product is going to look like. "**

## LINE

Line is an identifiable path created by a point moving through space. Your brush is literally composing a painting like a composer. Think of a conductor standing in front of an orchestra: They have a baton in their hand that they rigorously move about, controlling the rhythm of all the instruments. That's exactly what you're doing as a painter. You are literally moving your brush around and controlling the motion, the flow, the entire life force of that painting.

Lines can be actual lines or they can be implied lines. Implied lines direct the viewer to a focal point by using movement and direction; they are not necessarily literal lines but can be created through the use of color, form, light or dark, and spatial relationships. Focal points can have greater impact if there are guiding lines that build up to it and really highlight it.

This is a page from my sketchbook with a variety of swirly and squiggly lines. If you look at the lines in the painting on page 74, you'll notice these sorts of actual squiggly lines that I used around the perimeter to activate the canvas.

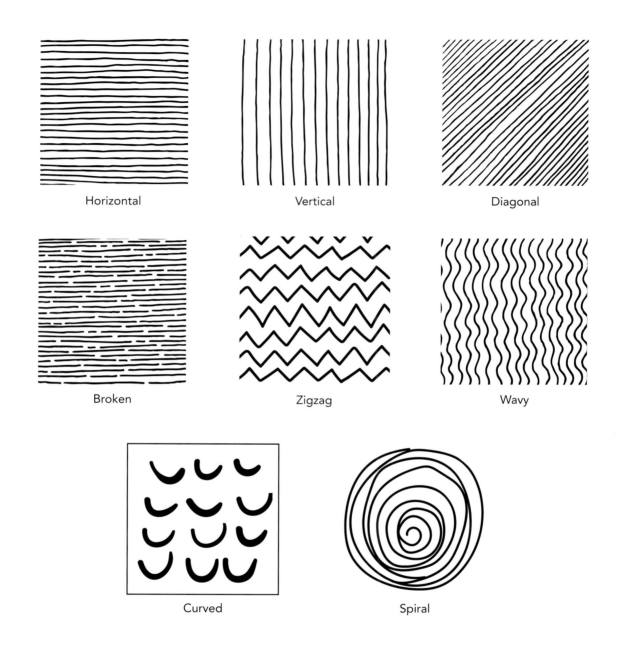

Horizontal

Vertical

Diagonal

Broken

Zigzag

Wavy

Curved

Spiral

Here are examples of eight different types of lines: horizontal, vertical, diagonal, broken, zigzag, wavy, curved lines, and spiral. When you repeat colors or patterns, you are creating a line whether you're intending to or not. Keep this in mind when you have repeating or continuous elements in your paintings.

Vincent van Gogh, *Starry Night*, 1889, oil on canvas, 28.7 × 36.2 inches

One artist who really homed in on the use of line to create a compelling painting was Vincent van Gogh. Take a look at *Starry Night*, above. Artists back then didn't have the huge range of beautiful colors that we have at our disposal now. They had to make do with the paint colors that were at their disposal, so van Gogh made this painting predominantly with blue, yellow, orange, black, and green. Look at the forms: circles, curves, buildings. Note the distinctive use of line in his work, leading up to different elements, shapes, and focal points.

By the time the Abstract Expressionist movement took off, artists felt at liberty to use scribbles and rigorous, bold lines to express the energy of the moment. We'll be exploring this in greater detail later on.

## WEIGHT

Weight is a force that attracts a viewer's eye, drawing the gaze to a specific section of a painting. This is something that you want to keep in mind in the work that you're creating. Where are the viewer's eyes going? Are the weights balanced?

How do you achieve weight in a painting? How do you determine whether the weights of your paintings are balanced? There's no hard-and-fast rule for this. As with composition, weight is something that you cannot objectively measure, as you can with color.

Size creates weight. A large form will have more weight than a tiny one. A large form can also be impacted by color value. For instance, if I put a large square of black on my painting, it's going to have a much heavier weight than if I put a large yellow square in the same spot—both of these choices will affect the balance of the composition in different ways. One of my favorite ways to create weight in a painting is through the use of thick texture (see page 120). Saturation impacts weight as well—neutrals or muted or pale colors tend to have less weight than saturated colors.

# Learn Composition by Cropping

The fastest way to practice composition is to paint.

I know you want me to give you shortcuts—and I'm going to give you as many as I can!—but, truthfully, you're going to develop your eye the more you paint, and it's only going to get better and better year after year. Let's try an exercise that'll speed up your process of understanding how composition works. I want you to find a painting—any painter's work online that you admire, one of mine, or one that you created. If you don't have a really successful abstract painting of your own or you don't do regular abstract work, I recommend that you pick a painting from another artist (these should be used for your own **personal exercise studies only**). You will be working on your computer or phone, so you need a digitized image of the painting.

Zoom into what you find to be the most interesting section of the painting. The section can be as small as you like: just zoom in, find an interesting area, use the crop tool to make a square or rectangle around the area, and crop it. What do you think of the new composition? Is it stronger? Just as interesting?

Once you get the hang of it with other artists' abstract works (if that is what you are using), try this exercise on your own paintings. It is a great way to quickly become prolific and become even more excited about every single painting you make. Nine times out of ten, there are two or three more paintings inside of each painting you make. Using this idea, you'll never run out of inspiration, because it creates a ripple effect.

Now it's your turn. See how many compositions you can create from just one painting. And then go paint them!

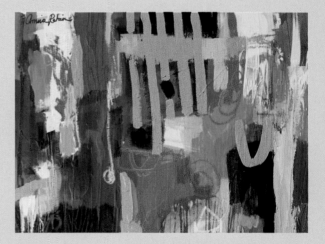

Opposite: *Machine Dreams*, 2015, acrylic on canvas, 40 × 60 inches. Here is a painting that I made a few years ago, one I absolutely hate. It was huge, about 5 feet wide. I was not accustomed to working on such a large scale, so it was a compositional challenge for me. It forced me to make some decisions that I wasn't really comfortable with, and I didn't feel like it was that successful.

Above is a detail of *Machine Dreams* that I cropped from the upper left corner; I like this much better. While the overall completed painting was not as successful as I would have hoped, I feel like this smaller section is a much more successful composition. Those blues and purples at the bottom create some nice heavy weight. And I love the elements of pinks and yellows and whites at the top.

## Abstract Compositions

One of the key principles of composition that is usually taught to figurative artists is the rule of thirds: using imaginary guidelines to divide the picture plane horizontally and vertically into thirds, and placing the structural and key elements of the composition along those guidelines. But what do you do when you are an abstract artist and you don't have any representational elements to map out? What do you do when it's just you, a whole lot of emotion, and a blank canvas?

To start, I want you to get into the habit of creating composition studies by drawing small squares and doodling compositions into them, like little thumbnail sketches. It also helps you get a grip on form, line, and weight. This is a great way to experiment and figure out compositions that work for you.

This should be your first step when creating a painting—don't start a painting without first sketching some of the energy out on paper or trying a few studies, as we did previously.

Studies are also a way for you to use a reference photo without slavishly copying it. Make at least three different studies based on your reference photo. Then either pick one as a jumping-off point for your painting or do a series based on your favorites. The point is to look at your study when you're painting, rather than looking at your reference photo. More often than not, you'll see that the sketched study will be more interesting than the photo, and you'll paint more freely.

Below are three sets of composition diagrams I sketched to illustrate basic compositional "hacks."

### Basic Hacks

Placing equal-sized objects in a row creates a pattern, while varying the size and placement of objects creates interest.

Objects that abut, instead of overlapping, imbue a composition with disharmony.

Using the rule of thirds in abstract compositions helps you create dynamic asymmetry.

In the first row of diagrams on page 80, which of the two compositions works better, and why? The one on the top right is generally accepted to be a more pleasing composition style. It's more balanced. When you have equal-sized objects in a row, you're creating a pattern; it is also visually static, the eye just moves in a line straight across the surface, with no tension. If you vary the size and placement of objects, you're creating a more interesting composition. Even though our minds are hardwired to look for patterns, they also find variety irresistible.

In the second row, which of these two compositions is more appealing to you? Most people choose the one with overlapping shapes. When two objects are bumping into each other but not overlapping, it creates somewhat of a discord in the brain. Perhaps there is something unconscious that makes people like overlapping shapes because they seem more unified. (On page 82 is an example of one of my paintings, *Evil Eye*, which illustrates the appeal of overlapping shapes.)

Finally, in the third row, the shapes are overlaid with "rule of thirds" guidelines. Which of these two compositions do you think is superior? The one on the left is usually considered more dynamic, and the reason is that you want asymmetry in your paintings.

It's better to put something a little off-center because that's going to create dynamic movement. This movement will flow through the painting and kind of dance around. If you look at the thumbnail sketch on the left, your eye moves on a journey as you discover and follow these shapes, whereas the sketch on the right has a shape in the dead center, like a bull's-eye—your eye goes straight there. That's not such an interesting journey, is it? There's no mystery; it's right to the point.

## FOCAL POINTS AND BALANCE

I like to make the analogy that a film can only have one nominee for Best Actor, with space for Best Supporting Actors. In a painting, you don't want to have too many things competing for attention, or it'll be confusing, unbalanced, and overwhelming—no element will stand out. Sometimes, less is more. Every painting needs a "hero," or focal point. In *Evil Eye* on page 82, the focal point is where the three shapes overlap and converge. Color can also have a powerful impact on balance, because anytime you add darker values like the Prussian blue in this painting, it acts like a fifty-pound weight. The lighter colors are like a twenty-pound weight. And the negative space (often white) is like a yoga mat—a place that gives you space to rest. (See more on negative space on page 83.) *Evil Eye* is an example of that balance. ■

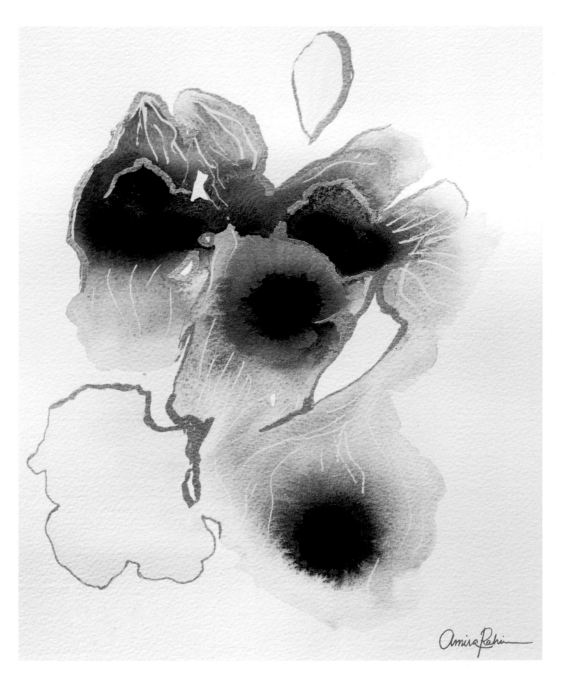

*Evil Eye*, 2017, acrylic ink on paper, 12 × 16 inches.
In this painting, the focal point is at the point
of convergence, and the dark blue shapes are
balanced by the interplay of negative white space
surrounding them.

## Focal Point

You don't have to have a focal point, but if you don't, then you will just be creating a pattern. A focal point can be located off-center or anywhere else in a painting that the artist sees fit. To create a focal point, follow these steps:

- **Use saturation.** You can create a strong focal point by using rich, saturated colors. Neutrals can be used to support/oppose/surround the most saturated area of the painting. This makes the focal point even more dramatic.

- **Create contrast using values.** Anytime you place a white next to a black value (or any two extremes on the value scale), that will create a focal point. Be sure to avoid creating multiple focal points using this technique.

- **Framing.** Create guiding lines around and leading up to the focal point.

## Balance

Achieve balance by keeping the following in mind:

1. **Weight.** Be mindful of the weight of an object within a painting. Be sure to balance heavy elements with smaller, lighter elements. In other words, avoid same-size objects in your painting.

2. **Repetition is your friend.** When used properly, repetition is the fastest way to achieve a cohesive painting that looks deliberate, not accidental. If you put one color or mark somewhere on the canvas, repeat it in another place. Use repetition in your colors but also in your mark-making.

3. **Color harmony is the final way to achieve balance in your work.** You want to make sure that your colors are all "related." This can be achieved by establishing a "mother color" and mixing it into all of the other colors in the palette (even if it's just a tiny bit). Tone down overly bright areas, where you need to, and adjust along the way.

## NEGATIVE SPACE

Next, let's talk about negative space. In a painting, negative space is any empty space on a canvas that gives the eye a place to rest. It's a good idea to incorporate negative spaces into your paintings to keep them from looking too busy or overwhelming.

You can achieve negative space with any solid color. Many artists use white to "edit" a painting and create some negative space. Almost every painting has SOME level of negative space. But there are certainly paintings where negative space is the resounding factor that brings a composition home. I like to think of negative space as akin to the sky. If you look at the sky, you really appreciate the trees and the buildings that you see because they're set against the nice blank canvas of the sky. Even at night, you have the velvety empty canvas of the dark sky as negative space.

**" Think about creating pieces with more negative space when you want to take the pressure off mastering complex compositions. It's a great way to have fun while creating a smooth balance in your paintings. Now take a peek at some of your favorite artists' work and notice if they use a lot of negative space to define their focal points. "**

Opposite: *Jade Blossoms*, 2018, acrylic on canvas, 30 × 40 inches. In this large piece, the flower-like shapes rest joyfully on a blanket of light-value neutral tones that create soft negative spaces around the floral colors. I added pops of white, but they stand out much more brightly against the neutrals painted in first.

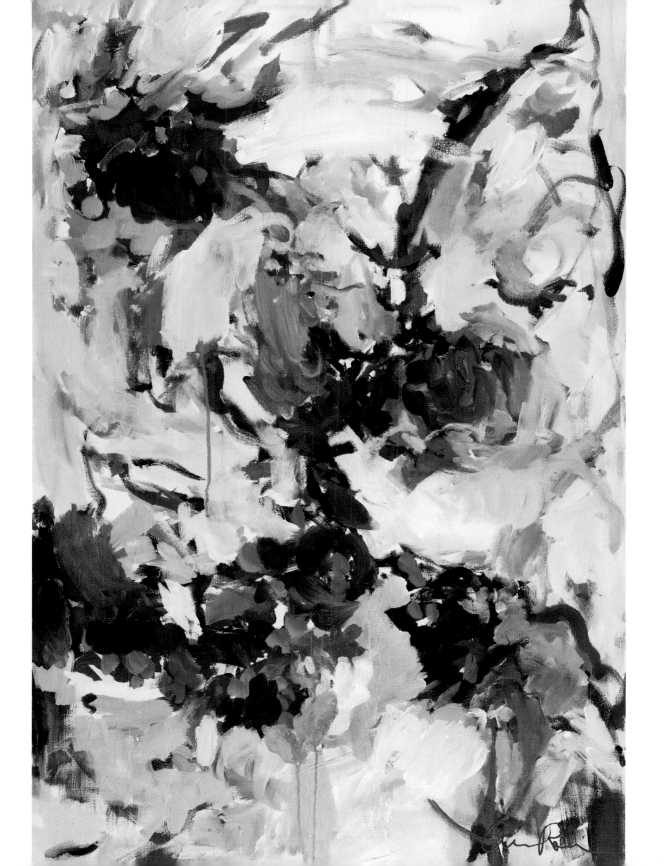

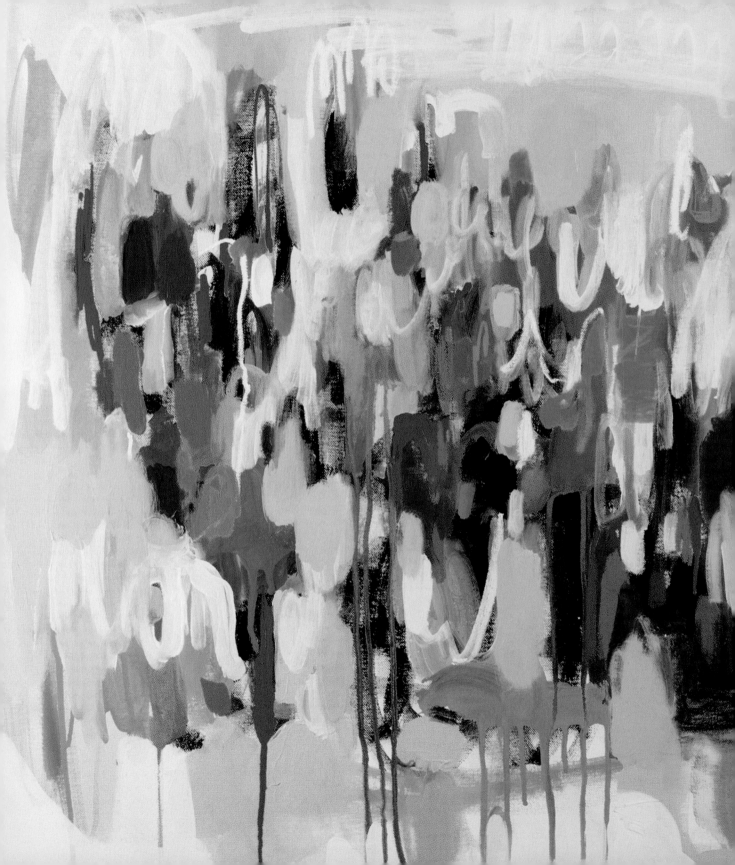

## Composition in Action

There is nothing that will teach you more about composition than examining the compositions of actual abstract paintings. Head to Etsy, Instagram, or Pinterest (or just search for *abstract paintings* in Google Images), and study the paintings you find to see which works successfully incorporate the compositional techniques we just discussed—and which ones don't. Study each painting and determine whether you like the composition and why. Is there asymmetry? Is the weight balanced? Is there a clear focal point? Did the artist make use of the rule of thirds?

*Memphis*, 2015, mixed media on canvas, 36 × 36 inches. You can see that whitish neutral space makes up most of this painting, while fun rhythmic explorations and drips form the festive center of the piece.

*Deep as the Ocean*, 2022, acrylic on canvas, 40 × 48 inches

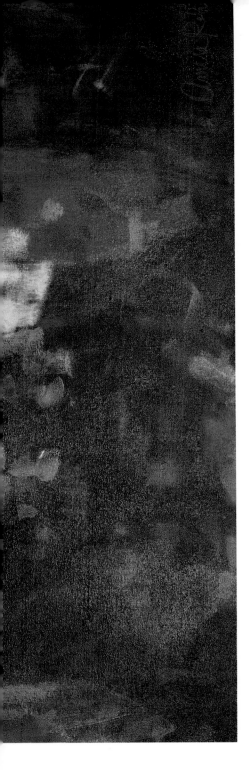

# CHAPTER 4
# COMPOSITION 201

# WORKSHOP 12

## Rhyme, Rhythm, and Repetition

In this workshop, we're going to focus on the "three *Rs*" to evaluate composition: rhyme, rhythm, and repetition.

I created this concept of the three *Rs* after about two years of being an abstract artist. I gathered different inspirations from disciplines like graphic design and photography, and married them with my love of music. I determined that by focusing on the three *Rs* of composition (rhyme, rhythm, and repetition), I could reverse-engineer what I was doing intuitively and have a clear explanation for why a painting works. The easiest way for me to do that was to borrow the elements of a well-constructed song. Just like a good song, a good painting is going to be composed of all three of these elements.

Let's break down the three *Rs* one by one:

### RHYME

I like to apply the concept of rhyme to color harmony in a painting. In most song lyrics, the last word of a line often rhymes with the last word of another line in the verse. The same thing applies to your paintings—you don't ever want to put down one color that has absolutely no relation to the other colors around it. No color in a painting is viewed in isolation, so you want to make sure that the colors relate to one another. Rhyme is the sense of color harmony. It can be achieved harmoniously by blending and weaving in sets of colors on your canvas for an optimal viewing experience. You want your painting to rhyme, to be harmonious, and for all the colors to mesh well together. Of course, this is a rule you can definitely learn, master, and then break as you see fit.

### RHYTHM

The next element is rhythm. Rhythm is the beat; it sets the pace of the song and it gives the song movement. So your job as a great abstract artist is to do the same thing. You wouldn't be able to dance to a song that had no rhythm.

If we look at *Samba em Salvador* on the opposite page, you can see the rhythm in the movement of shapes and colors. Notice how your eye moves up and down and around the painting. If you look at where the pinks are, you can see them on the top left, going across the top, coming down around the right side, reemerging at the very bottom, and sprinkling over to the bottom left. The greens move diagonally, crisscrossing through the plane. So there's movement throughout the canvas—I'm guiding the viewer to exactly where I want them to go.

Also, my brushwork is well-defined and there are clear distinctions between the colors; that's really what you want to go for. You don't want to just layer color over color over color when it is

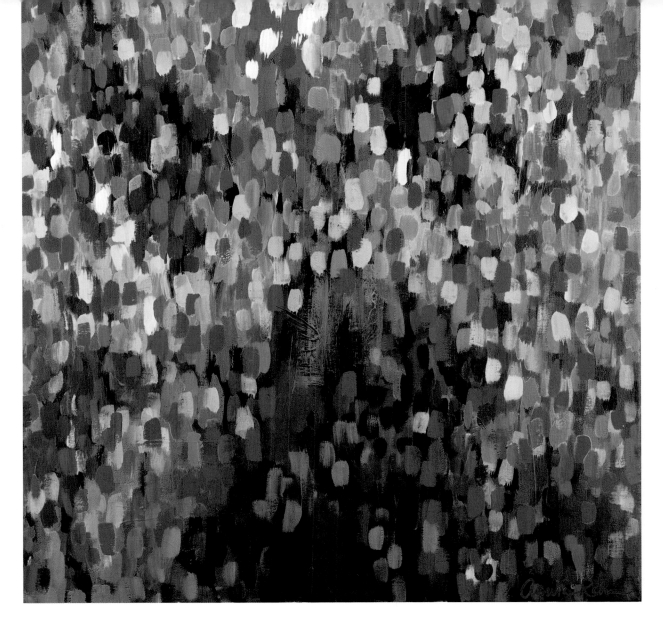

*Samba em Salvador*, 2016, acrylic on canvas, 20 × 24 inches. Let's look at the rhyme in this painting. You can clearly see that the colors are harmonious, and the easiest way that I achieve this is by lifting the colors around the focal point (see pages 63 and 100 for more on lifting). The middle portion here has a blue-green color, but the more you look at it, the more you can see all the different shades of greens and all the different shades of blues that I was able to incorporate into that form. That gives it a nice harmonious feel.

wet—you will get stuck with mud if you do that. You're not going to establish any rhythm and it will fall flat. The trick here is to lay the color in and move on to another section or let it dry. You can always go back into it later on, which leads me to the next *R*, repetition.

## REPETITION

Our brains are wired to see patterns. From an evolutionary biological perspective, being able to quickly recognize patterns of dots on a plant or identify the stripes on a predatory animal was once the difference between life or death.

Repetition is the building block of any good composition, whether it's a painting, a photograph, or other artwork. Why? Because repetition creates familiarity. The chorus in a song is repeated after each verse; as it becomes more familiar, it turns into a hook. Repetition is a powerful element of composition because it creates cohesion and comfort for the viewer. The trick with repetition is that you don't want it to feel robotic. For example, in a song, when you hear the chorus in the later part of the song, it'll have some variations—they'll punch the notes up a little bit more or do more harmonizing. But it's still the same chorus, the same skeleton, but it doesn't feel robotic—it feels alive.

Let's look at my painting *Samba em Salvador* on page 91 again to evaluate repetition. In this case, repetition is achieved by the brushwork. I employed the same shape using the same size brush throughout this entire painting. And I repeated it all across the canvas. I broke up the color in an Impressionistic, Pointillist style, using my brush to get those stiff, squarish strokes. (Note: You can try this with a round brush, too. There are many different ways to create this pattern.) So it creates a sense of pattern, a sense of repetition, which makes it accessible and easy to understand. It's not complicated, it makes sense, and the viewer can simply fall in love with the colors, the pattern, and the movement.

Earlier we discussed the concept of color as form itself. With this in mind, it makes sense to repeat color as an element in the painting. This repetition can give way to new compositions and patterns throughout your work. Keep in mind, however, that blindly repeating a formula will look too robotic. Within seconds, we become bored because the pattern lacks variation and mystery. I like to avoid falling into these subtle traps by alternating between big, wide brushstrokes and small- to medium-size brushstrokes. You can simultaneously create cohesive, repetitive movements as you structure your painting, while allowing for elements of surprise, or Bob Ross's "happy little accidents." This is the blurred line between the art and science of a painting. ■

"If you heard someone performing a song and they were just playing random notes, it would just sound like music practice— it wouldn't sound like a full song. In the same way, we need to paint with rhythm to create a finished-looking painting."

# Apply the Three *R*s

Now it's time for you to dissect some of your favorite paintings and see how the three *R*s apply to them. I'm going to show you exactly how we can do that with a few examples from abstract art legends.

Go online and google the painting by Joan Mitchell titled *Begonia*, from 1982 (viewable on the Joan Mitchell Foundation site). A lot of people feel that Mitchell's work is chaotic and all over the place. But notice how harmonious her colors are here—there's no one color that seems like it doesn't belong. Mitchell was a master colorist. She knew exactly where to place that pink next to that orange next to that yellow, and then those greens right next to that yellow and even down when you get to the bottom with that blue. It's not ultramarine blue or bright blue. It's a dark blue and it doesn't feel out of whack. It doesn't feel problematic. And yet it adds a nice element of surprise and contrast. So the rhyme for this painting is on point.

Let's check for rhythm. Does the painting have movement? Is the artist making your eyes dance all around the canvas? Absolutely. And Mitchell was the queen of that. Her work is typically very gestural, full of movement and energy.

Let's look for repetition. Do you see any repeating elements in this? I certainly do. She's repeating those touches of green from the top, all the way down to the bottom, the touches of yellow. The texture and the brushwork is so well-defined and -developed that it doesn't just feel blurry; it feels like a pattern.

Next, look up Willem de Kooning's *Untitled V,* which he painted in 1980. This painting is also gestural, very thick, and very visceral. You can clearly see the three *R*s being applied.

It has rhyme: The colors all mesh well together. It feels harmonious. There is a clear decision to make this turquoise green the star of the show.

It has rhythm: Notice the movement he achieved in his brushwork. Observe how your eye dances across the page. Look at how deliberate he set the pace of that painting. It has a slithering type of movement, but it's very heavy and consistent.

Finally, it has repetition: Notice how he repeats this green strip throughout the painting in different directions. There doesn't seem to be a clear focal point, but if I had to pick one, it would be the bottom-right quadrant because that's where the viewer's eyes go. Do you see the hint of coral orange? Is it in one spot, or does he carefully repeat this color in other places nearby as well? The brushwork is super consistent as well.

So as you're painting and layering away, make sure you're creating repeating elements throughout your painting. Ensure that it rhymes. Make sure that it has some rhythm. Create some movement, and then repeat, repeat, repeat. Repeat it in certain areas, bring it to the other side of the canvas and repeat it over there. This is why I see so many artists rotating their canvases as they work because it allows them to take that

same hand motion and carry it to different areas of the canvas.

Your next assignment is to find five abstract paintings that you love from living artists. Now that you have the tools of composition and color, you can dissect their painting so you can steal like an artist. I want you to break down each painting to determine how they achieved the three *R*s. Now you're thinking like an artist!

**Just as spontaneous and fluid as a cat's movements can be, so, too can your artist's hand. Wielding a paintbrush with courage is required to land on your feet gracefully in this process. Let's keep exploring ways to loosen up and make magic.**

# WORKSHOP 13

## Finalizing a Composition

The photos on the opposite page show the stages of a painting study from a live demonstration as I worked on it. A collector had fallen in love with the work before I had completed it, so I could not change the composition drastically—I just needed to uplevel and finalize it. I will recount my thought process as I went through the revisions.

**Figure 1 shows what we are starting with.** First, I look for areas that can be improved. I like this composition for the most part, but I want to do something that I often do in the latter stages of a painting: Go in and lift the color. When I lift the color, I enhance what's already on the canvas by adding more illumination or vibrance to it, just sort of spice it up a bit more. This doesn't take long, but it's something that I do as I'm finishing a painting to transform it from good to great. I like to constantly push boundaries and go above and beyond expectations.

To begin, I go over the deepest parts of the magenta and I add a tiny bit of white. I rework that area because acrylics tend to dry darker. If you're coming from an oil painting background or a watercolor background, or even alcohol inks, you may find that you don't like acrylics at first because the colors look good while you're painting but you come back the next day and everything looks flat and less vibrant. You're not doing anything wrong! Even with the best-quality paints like Golden, it's still going to dry a little darker. So I like to lift the colors by adding another layer to make them even more vibrant.

For this reason, it's very rare for me to make a painting in one sitting that is ready to sell. I love hearing my collectors say, "Oh my gosh, the painting looks so much better in person!" And I know you want to have that reaction from collectors, too.

Next, I go over that orange bit in the upper left corner with some white, because I feel that it didn't really add to the composition. I'm editing at this point. Then I take some yellow and pop it next to the orange to bring the viewer's eye down a little bit more. Repetition is a huge part of my process when completing compositions. I use the same brushwork at the bottom left that you see with those yellow dashes, and again at the top. **See the results so far in figure 2.**

I want to add some hints of green, but I mix it with some other colors first. I don't generally encourage people to use a color right out of the tube. It's always a good idea to mix and match as best as you can to see what new colors you can create. I take a tiny bit of that green, but I don't want it to be too saturated, so I add a little bit of that magenta to sort of gray it down a little bit. Now I can go in and layer over those blue and green areas with some more light green, but it's still pretty saturated and I don't want to distract from the magenta

Figure 1

Figure 3

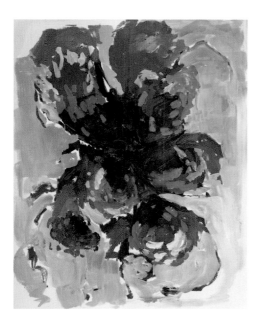

Figure 2

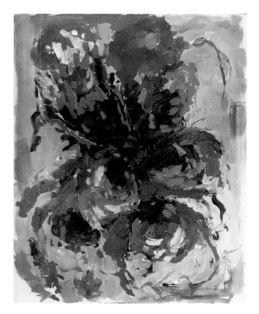

Figure 4

flower-like forms. I add a little white, doling it out carefully so as not to distract from the bigger picture. It's not a pure, stark white—it has the green mixed in. But it's enough of a value shift and, most importantly, it desaturates the dark colors.

At this stage, it's really important for me to make my darks dark and my lights light, so I am going over the darkest areas of my painting and bringing them back to the surface, redefining those darkest areas so that my values are nice and contrasting. Then I lift the Prussian blue in some areas so that the darkest darks are really pretty much right in the middle, where the focal point is. **See figure 3.**

Because the painting is still wet, there's not a ton I can do further with paint. But for the areas that are dry, I can go in and have fun with my acrylic markers. These are an easy way to add some detail into your paintings. When someone looks at your work from afar, you need the composition to be compelling enough to draw their attention. It needs to be simple and catch the viewer's eye, but then when they come up close they should discover little surprises.

I add little white marks into that light periwinkle color, because it's similar in value to white. This gives the illusion of detail. It feels floral and fun, but it also feels designed, intentional, and mature.

It's fun to play around with some value opposites at this point. For example, I draw in a few light blue areas because I know that light blue will really pop over navy blue. It feels very layered and developed. And I can even incorporate some of that into the middle part of the painting. Now it's really making it seem like a detailed flower. What's funny about this is that I did not even look at flowers when I was painting this work! I don't have any reference photos—I'm just painting from the soul. And it's so abstract that if these turn out to be the worst flowers ever, I give myself permission.

Next, I make random tiny dots. Once I've done some on one side of the page, I continue those same movements on the opposite side of the canvas, going for repetition and balance.

**The final result can be seen in figure 4.** I stand back to assess: We have our focal point. We have our balance achieved. We have rhyme: The colors are cohesive and work well together. Nothing is too loud. Nothing is standing out and drawing too much attention. We also have repetition because blue elements continue around the canvas—from those made with very big brushstrokes on the bottom right corner down to the tiny little marks. The rhythm is achieved with the general movement of the painting itself. There's enough interest all around the canvas to make the viewer's eye dance around the canvas, even up to the green leaves. ∎

## Painting Makeover

Take a half-finished painting that you were thinking of scrapping. Instead of stowing it away in the closet or completely painting over it, try lifting and layering your colors and adding tiny details. See where it ends up—you may end up loving it! Have fun with it!

# WORKSHOP 14

## Evolving a Plain Composition

This lesson is a painting demo to show you how to develop a plain composition and improve it. I'll be sharing the kind of decision-making that I do as I paint.

I create a large color field in red . . .

I begin by wiping Prussian blue across a piece of canvas paper. As discussed on page 67, it is traditional to start with darks in the background and go lighter as you go through the process, so that is what I am doing here.

. . . and a second color field in orange, and then add a large swoosh of yellow. Right now it's a pretty simple color-field painting, consisting of two big shapes. Now, imagine if I left this painting as it is—called it a color-field painting and moved on. That would be completely fine. But I want to create more elements of surprise, details that entice the viewer to look more closely. I believe these simple elements play a big part in transforming an abstract painting from looking basic and amateur into something that's visually stimulating.

I load up my brush with magenta and create some sweeping strokes to activate the page. Because the magenta is transparent, it is creating some nice depth and interest.

I take a small, dry brush and load it with pink paint. I've chosen pink because it will lift the red. Anytime you are going to layer a pastel color over the purest version of the related hue, things become more interesting. Holding my brush loosely and by the end, I lightly dance in some shapes and random lines with the pink. Notice how I paint around the edges of the red shape, instead of adding pink into its center. I want to keep the composition consistent because I like the simplicity of those two large shapes.

What should I do next to make it a little more interesting, a little more elevated for the viewer? I feel like these look like sunset colors, so I take a little bit of dioxazine purple and add some white to it to illuminate the color (otherwise, it's going to look like I'm just adding black). I want this purple to be pretty obvious. Next I move to the perimeter to make it more exciting. I mix more white into the purple and add some of that as well. This way, the hot, fiery, orange and reds are balanced out with some cool tones. I think the purple looks good, but it can probably go a step further. I add more pops of green and blue. Once again, I make marks around the perimeter to create tension.

As we discussed earlier, the only thing lighter than yellow is white. So I take some white on a dry paintbrush and apply it just on the yellow. I decide, though, that I'd applied a little too much white. I want that yellow swoosh to be a prominent feature, and the white overshadows it. No problem—I take some cadmium yellow right from the tube and reestablish the dominance of the yellow swoosh. I heighten the tension within the orange color field using a fun trick: I make marks on it with an orange oil pastel. You can see the marks because the oil pastel is a slightly different color from the acrylic. This results in a subtle scribble effect that provides tension, electricity, motion, and energy. I take it one step further by lifting the color. I add a little bit of a more vibrant orange (the oil pastel) and then lift the yellow next to that with white. I lift the deep magenta with some touches of pink, and the dark purple with some light purple and lavender. I also lift that deep magenta with a different hue altogether—turquoise blue.

As I'm painting, I check for rhyme, rhythm, and repetition. I decide that green isn't present enough, so I grab an oil pastel. If I put this green on the red, it'll clash and draw attention, since red and green are complementary colors. I don't want that here—I want to maintain the two large color fields and work on building up tension around them. So I apply the green next to the blue, which adds interest to the perimeter and elevates the painting. I want to add more white, but I can't just add it anywhere or else it'll completely change the

composition. I apply some white to the lightest areas around the perimeter, creating little accents and highlights. I decide it is done!

## Mindset Check-in

This is the perfect time in your progress through this book to check in with your mindset. You've absorbed a lot of new information and ideas about the painting process.

I believe that painting is not only creative and artistic, but also spiritual. It's a very personal process, because, for the most part, we paint alone. So a lot of things can come to the surface as you're trying to express your vision. Therefore, it's very important for you to know how to navigate those emotions when they arise. Mindset work is something that you will be doing for the rest of your life, especially if you want to constantly push beyond boundaries and reach new heights. Most of us have artistic goals, but it's hard for us to articulate them because we don't know what we're capable of. We don't know what our potential is.

I want you to imagine that you're walking through the woods, passing by trees and hopping over logs that are in your path. It's an uncomfortable walk because it's icy cold out, and there's snow on the ground. Then you get to this beautiful stream, flowing with infinite creative potential, infinite creativity.

What is this stream? You can call it Infinite Light or Source Energy; it's a bottomless well of color, joy, ideas, and expression. Dip your toes in it, let your whole body float in the waters of life.

You can even fill up a vessel from that stream and take it back to the studio.

I drink from this same stream. I believe we can access this stream from within at any time of our lives with deep meditation and intention. But it's important to note that if you haven't been actively painting for a couple of months or years, it may take you longer to get to that stream. You may have lost your way as some new weeds block the path. Even though the journey to the stream takes a little longer, you arrive and rejuvenate yourself in the stream. You can go back to your studio feeling refreshed. You feel so quenched and nurtured

when you drink from this beautiful stream of creativity. When you get back to your canvas, you're overflowing with love and you're totally present because you filled your well from the stream.

When I don't refill my well and access that creative stream regularly, I may run into some resistance. I may run into some trouble. When I go to return to the stream, I may need to forge a whole new path, battle wild animals, or pull up weeds. I may become too cold or exhausted and fail to make it to the stream. I may have to return the next day to try again, but eventually I'll get there.

Even though you may have given yourself a deadline to launch a new collection—or even to finish this book—your creative practice is a lifelong process. You might think, I don't know if I'm capable of doing this anymore. I don't know if I have what it takes to make beautiful work.

Know that even the confusion and uncertainty, too, are part of the process.

I feel that way sometimes, but I am able to get over it with some adjustments to my mindset. I know that there is always a way out of a tight spot—and that the core of creativity is about problem solving. Working on your mindset is as important as working on your painting skills!

How do you work on mindset? The difference between a confident artist and an artist who is not confident is our **internal dialogue**. It's the conversations we have with ourselves about what something means. At this stage in my art journey, I have evidence from the outside world to support the belief that I have developed about who I am as an artist. If I make a bad painting, it doesn't phase me. I know by now that you have to get the bad paintings out before you can get to the good.

But I also remember when I didn't have that belief in myself as an artist, and every time I would make a bad painting, I would think, I'm a bad artist. My internal dialogue would be: This is hard. This sucks. I can't do this. I don't know if this is even worth it. Maybe I should just find a regular job. I don't want to put myself through this.

Fortunately, through years of mindset work, selling my art, and becoming more confident and comfortable in what I was doing in the studio, I realized that my studio is the best place to manifest. Let your studio charge you up.

Light some candles, burn incense. Fill the walls with your work and other art that inspires you. Put a chair outside the door. That seat is where fear is going to sit. Fear is going to have a seat and you're going to say to yourself, I hear you, fear. I'll get back to you later. I'll indulge you tonight, but not here and not now. When I'm in my studio, you don't have a seat here.

Let's be honest: Abstract painting is much harder than it looks.

When you are in a loop of frustration or negativity, you might feel sad and defeated. This can hit you while you're trying to work in a new style. Your brain may even push you to think: Perhaps I am the worst artist in the world.

But can I share my biggest epiphany that I used to break this thought pattern?

It was almost ten years ago, I was still painting in oils, desperately trying to create the perfect still-life and representational look, like all the other daily painters I saw online. I was so ashamed that I could not effortlessly create flowy works on

10 × 10–inch panels, crouched over my easel for hours. But I knew I wanted to be an artist.

And even if I was a bad one, I was still going to paint.

How many of us have gone to terrible doctors or had bad teachers? But, guess what? As bad as they might be, they still have the right to call themselves doctors or teachers.

So, from this day forward, own the fact that you are an artist. And leave the judgments behind. You'll receive plenty of feedback along the way.

You can replace those negative thought loops with some positive self-talk, like the affirmations below:

- I'm discovering all of the colors that I love truly to my core. I'm figuring out how to use them in new ways each day.

- I love wrestling with the paint and exploring the problems I need to solve on the canvas.

- I'm creating paintings with an open heart, bright eyes, and healthy fingers. I am grateful that I have the mental capacity to grasp new ideas and challenge myself.

- I love looking at a fresh new canvas and seeing what opportunities will pop up each day.

- My studio is my safe place. I only have to share my art when I'm truly ready.

- I enjoy knowing that the faster I get all these bad paintings out the way, the faster I can get to the good ones!

- I love knowing that my mentor has already walked this path and figured out how to get to the other side artistically. I love knowing that I'm finding my voice just as she found hers and I'm confident in my dedication to this work.

- I am surrounded by artists who are a few steps behind me, a few steps ahead of me, and also right where I am on the journey. I'm never alone in this process. We are one. ∎

# "Your studio is an absolutely magical place. Hold yourself responsible for trusting that you, too, have the power to create your own reality. "

Anytime you feel that you need a mental break before starting your day, pull out your journal and just write down what is on your mind. Julia Cameron, author of *The Artist's Way*, calls them "morning pages" (see page 13). But you may also find yourself needing to release the baggage of the day before bed as well by writing in your journal. See where you are and do all you can to shift your thoughts in the direction that will move you toward your goals.

## INSPIRATION IS OVERRATED

I know, I know . . . I'm an artist, right? I'm not supposed to say that inspiration is overrated.

I get asked from time to time: "What inspired this piece?" I'm supposed to come up with a great intellectual explanation. I've attended workshops and art seminars on storytelling, and artists are rightfully advised to sell our work always with "the story" behind each painting. Be it fact or fiction, we must relay some sequence of events, preferably starting with obscurity to sudden clarity, as if that could somehow justify the finished painting.

Can I be completely honest with you?

I'm not really fond of that question. Not because I lack "inspiration," but because my art practice is not a linear one. I paint in cycles, often working on several canvases at once. Some end up in the proverbial trash bin, and others make it to the other side. And, guess what? I have no idea which pieces will be the successful ones.

So, I'm just going to call BS on the whole inspiration thing, and here's why.

We tend to think of the creative process like this:

**Get inspired —> Paint**

**—> Beautiful Result**

But mine, on the other hand, goes more like this:

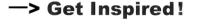

**Paint —>**

**See Something Beautiful ***

**—> Get Inspired!**

*after several false starts, mess-ups, and shortcomings

And that inspiration, man, when you find it, you'll know. I reject the notion of a singular idea leading to a singular painting—that some genius idea grabs hold of us and doesn't let us rest until we execute it to completion, and then we are out of work until the next big idea strikes.

Perhaps painter Chuck Close said it best: "Inspiration is for amateurs. The rest of us just show up for work."

So in the spirit of showing up and getting to work, I wanted to leave you with five ways to consistently cultivate your creativity so that you'll be equipped the next time you find yourself slipping into artist's block.

## 1. In the Process

**Cultivate your creativity in the process of painting, itself. Paint for painting's sake.** Painting is one big playground. Give yourself permission to get out of your own way, relinquish control, and just go for it. I'll be the first to admit that, a lot of the time, painting is just experimentation. When I'm painting, my subconscious chatter probably sounds like this: I wonder what would happen if I placed this color here, or scratched out this layer, or added in this texture.

Usually, I am just so inspired by the process itself. I'll have a song stuck in my head, or a line repeating from a book I'm reading, or I'll be in the flow and random memories will just pop up into my consciousness. And then, BOOM! I'll think of a title for my next piece. There's the feeling I'll want to convey—or the end result starts to form and I'll know what to edit out and what to take up a notch. I guess what I'm trying to say is this: Painting is fun. And I don't have to have a reason to do it every time. Sometimes, just being with my paints in front of a white surface in my sunny studio, with a good cup of coffee, is all the inspiration I need.

## 2. In the Hope

**Cultivate your creativity in your hopes and dreams.** Another misconception is that the way a painting looks illustrates how the artist was feeling while painting it. Gosh, wouldn't that be convenient? If happy paintings only came from happy people? I deliberately use happy colors in my work and people often assume, "Oh, you must be so happy to create such joyful work."

This couldn't be further from the truth. I've created some of my most cheerful paintings when I was really, really sad. And what a relief it is to know that my work doesn't have to depend on my emotional state. I can tell you that, if it did, my body of work would be all over the place, because that is the human experience. We're not consistent. But I believe our deepest, core desires are. No matter what your emotions on a given day, you can use the process of painting as a healing one and create art that will lift your spirits by the time you are finished. And that, in my opinion, is the most empowering thing about being an artist.

### 3. In the Rest

**Cultivate your creativity in the rest.** It seems counterintuitive, but pulling back and allowing yourself to live outside of the studio is very important. Go out. Travel. Spend some time with yourself. Spend time with friends. Watch a season of something ridiculous on TV. Chill. It may not give light to a new idea, and that's okay. I've learned that creativity is a muscle, and while challenges like painting thirty works in thirty days and showing up regularly can definitely build your endurance, you can overwork it. Rest from being so damn inspired all the time. Rest from art. And searching. And feeling so much. Because, man, are we a sensitive bunch!

### 4. Through Your Previous Work

**Cultivate your creativity through your previous work.** This is super key. In fact, this should probably have been number 1. As an aspiring artist, in the beginning you're trying to find your style and your voice. And, naturally, so much of that is looking externally. But a key turning point in your art practice begins the moment you start to look inward. Truly inward. Your paintings start to speak to each other—especially if you're painting on multiple canvases at once, or painting in a series (which I highly recommend). This is when you're truly independent as an artist. And the freedom that you feel in that moment, even if just for a day, is one of the best feelings in the world. You're feverish with ideas. And you can't paint fast enough because you're just so into your own journey. You don't have time to second-guess yourself. You're too busy painting your heart out.

### 5. Via Your Peers

**Remember: Creativity doesn't have to happen in a vacuum.** If you are truly lost and devoid of anything exciting, browse art marketplaces and social media platforms like Pinterest. Study art history. Go visit museums and look at the art movements that came before more contemporary voices. Go to a local art class and try something different. And, most importantly, try to find gaps in the market. A concept you can bring back to life with a new twist, or a subject that's never been explored before in a conventional style. That's where you can find your place. And that's how you steal like an artist.

*Untitled*, 2019, mixed media on canvas, 30 × 40 inches

# BUILDING LAYERS IN YOUR PAINTINGS

# WORKSHOP 15

## On Your Mark!

I believe that our composition choices can be a direct channel to our immediate emotional response to our painting process.

What do you mean, Amira?

There are certain emotions that we cannot escape as humans. All of us have felt anxiety at some point, or the feeling of heartbreak. And all of us have felt moments of joy and bliss. I believe those emotions can be transferred to and through the canvas, and that this transference of energy is enough. Emotions do not have to morph into a representational form.

Imagine a world where you no longer have to question if your work "moves people." Your process is so alive that it moves you. I also feel that this may be a very risky way of creating art. It requires you to be present. To be willing to look stupid. To make mistakes. And to recover from them, again and again. The marks you make are as personal as your handwriting. But we can start to synthesize some common themes we see in abstraction, and I will leave it up to you to assign your own personal meaning and thus interpretation to the work.

On this page and on pages 111–13 are an assortment of marks I've used to help me get comfortable with creating complex and emotional abstract compositions. Feel free to grab a paint marker or writing tool and create along with me as I go through the language of each type of mark.

### FLOW AND WATER

We're starting off the mark-making discussion with the simplest of strokes to understand. In this style of horizontal fields of color marks, you are quite simply "going with the flow." They can be as detailed as Claude Monet's water lilies or as daring as Mark Rothko's thick blocks of color. (For further inspiration on this, check out Rothko's work. If you can see one of his paintings in person, it's definitely worth the trip. His color-field paintings best embody the simplicity of flow and color expertise.)

I start by making some horizontal lines, varying them in width and vibration. Like water, the lines can be rapid and wavy, or still and ripple-like.

Using a thick, round brush, I work some Prussian blue and dioxazine purple across the page.

I continue this same pattern vertically, experimenting with different tones of color and value. In the study above, I use greens fading into pink. The piece is quite neutral overall, but I let the dark value of Prussian blue at the bottom balance out the overall weight.

## CHAOS AND ANGER

This form of mark-making is a favorite of mine. For many of us, abstract art is a way to release our emotions and express ourselves. And we all feel anger from time to time, even if we've been conditioned to hide and suppress it. When you create jagged, disordered, chaotic lines, you're unleashing your anger in a healthy way. You're saying on canvas what you might never allow yourself to say aloud. As Julia Cameron says in *The Artist's Way*: "Anger is fuel. We feel it and we want to do something."

I remember the first time I stood in front of a Joan Mitchell painting at the Whitney Museum in New York. The large scale of her paintings and their fierce explosion of color are truly awe-inspiring. I believe that people resonate with paintings with these kinds of marks because they can see that it's pure, raw, uninhibited emotion—the kind that we rarely get to express publicly as adults. There's a good reason people say that painting is therapy!

Refer back to Workshop 3 on pages 22–25 and your isolated influences and see if any of the paintings you chose give you the same feeling of wild, unapologetic freedom.

Take whatever color you choose to start this study. Using a mid-size short filbert, I start to scribble and release energy here. I also use a navy blue acrylic marker at the top to really establish a sense of chaos at the outset. This is so freeing!

Next, I take a reddish-magenta marker and use it sporadically across the surface to add some detail. The key thing about this style is varying the *size* of your strokes as much as the movement. Fat lines, wobbly lines, and tiny little screams are all welcome. I layer in some pinks and greens before forming a disarray of purple in the middle. I admit, this style of painting, although a favorite of mine, does not come easily to me. But I still wanted to present it to you because you may find that some mark-making styles come naturally to you while others require more thought and constraint on your part.

Ultimately, I mix in some white while the green is still wet on the page, letting the white be tacky and immediate. Finally, I fill out the top right of the painting with some yellow, just to brighten up the energy and take it to a new level.

## PATTERN PLAY

Even though painting is an essentially relaxing activity, there are times in life when you may find yourself drowning in anxiety and overwhelm. You know you "need to get in there and paint," but some days you are so frustrated that you would rather take your palette knife and jab holes in your canvas. I've been there, and I turn to one of my most popular styles of mark-making in those instances: pattern play.

This style of mark-making is very forgiving. You can get away with a lot and you don't really have to be an expert at painting in order to create a satisfying painting. Plus, it is a great way to work on your color skills! Remember that if the colors start looking disjointed, mix new colors with some of the colors that are already in the painting—this creates cohesion.

Evolutionary biologists report that the human brain is wired to look for patterns. Sometimes, working in a set order can help you feel less anxious when you don't know how to start or finish a painting. See how I did this in the following examples.

Next, I add more layers, this time with viridian green and also a touch of white. I start to fill in wider spaces with my flat brush in some areas. Getting nice big chunks of color, a beat is starting to form. Thump, thump, thump.

Now, with a slightly smaller-sized brush, I mix some more white into my blues and repeat the strokes. Notice how the repetition is already occurring in the painting. I allow my mind to relax a bit and just enjoy the springs of color that form.

Next, I incorporate whatever colors I feel instinctively, but keep my values dark. For this study, I choose to incorporate some purples before adding more greens. I work in pops of magenta and yellow—randomly, but I am still carefully aware of where the viewer's eye will go. I love how the Prussian blue background creates a depth of field within this mark-making technique.

Using a flat brush, I start off with my darkest value of Prussian blue. I drag the brush vertically in a downward motion, repeating this randomly but consistently across the canvas. The key to this technique is to create a tight design, making sure that it is not so predictable that it becomes symmetrical.

I continue to layer pops of green, orange, and pink, brightening up this piece stroke by stroke. Finally, I add some small dabs of white with the edge of my brush.

## SENSUALITY OR THE DIVINE FEMININE

The next style of mark-making is kind of like interpretive dance. Have you ever seen this style of whirling movement, arms trailing, wild and free? You can adopt this technique when you want to loosen up and tap into the sensuality of your dancing spirit, of the goddess energy of the divine feminine. Put your favorite music on and take a look at some de Kooning work to get inspired.

For this study, I start with the passionate blood of magenta. I hold my brush closer to the end, like a wand, instead of up close, like a pencil. There are no geometric angles; everything is soft. There's something peaceful and freeing as the marks emerge on the canvas. You may even start to see figures through the marks, inviting you to dig deeper.

I add orange marks across the initial magenta strokes and wrap them up to the top, still playing and loose. Next, I mix a bit of phthalo blue and dioxazine purple to create a light violet color. With the same brush, I drag it across, left to right, and then down and up. Be sure to wash your brush and dry it off in between colors. This keeps the paint tacky and allows you to work wet-on-wet. I follow the orange with yellow. While the paint is still wet, I get some white thick on my brush and go over those same strokes, allowing the colors to mix naturally on the canvas. Remember, there's no perfection here. You don't have to blend or smooth anything out. Just feel the movement.

I love the pink here, so I decide to add more white and create another pass of color across the surface. You can still leave some of the layers underneath peeking through: this imparts nice depth as you build up your composition. Since green is the complementary color to red, I choose to add it in as an accent—but not a green straight out of the tube or in its most saturated form. I neutralize/gray it down, mix in some white, and then lightly stroke it onto the painting.

Finally, I work more yellow into the top. Notice how the yellow strokes next to the magenta and orange strokes instantly add heat to the canvas. You can play with the balance of warms and cools in this style of mark-making to create tension in your work.

### Mark-Making Gallery

On pages 114–15, I have assembled examples of some of my finished paintings to further illustrate each of the mark-making styles we just discussed.

The painting on the bottom left of page 115, *The Moon Pulls the Tide*, was born out of complete frustration. I was trying for a more colorful piece (still visible in part on the underlayer). After several failed attempts, I "ruined it" with the pattern-based brushwork and simple blue color scheme seen here. I was pleasantly surprised with the outcome, and it promptly sold to a collector in Malaysia. Sometimes, your best work and most innovative compositions will come after agony and confusion. Don't give up and don't beat yourself up. ∎

## Flow and Water

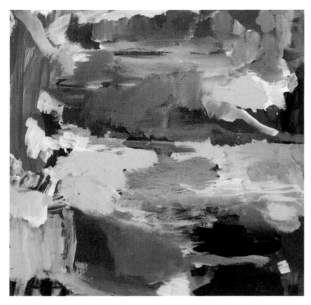

*Promise*, 2017, acrylic on canvas, 16 × 16 inches

## Chaos and Anger

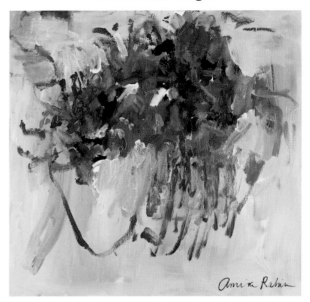

*Two Can Play That Game*, 2018, acrylic on canvas, 16 × 16 inches

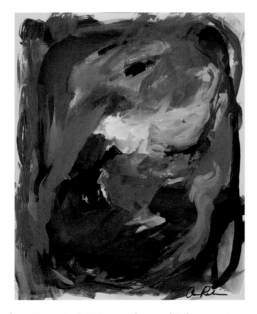

*Monkey Forest*, 2017, acrylic and ink on paper, 16 × 20 inches

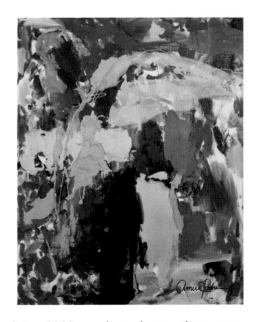

*Fire & Ice*, 2022, acrylic and enamel on canvas, 22 x 28 inches

## Pattern Play

*Date Night*, 2017, acrylic on canvas, 20 × 24 inches

## Sensuality or the Divine Feminine

*Womb 1*, 2018, acrylic on canvas, 16 × 10 inches

*The Moon Pulls the Tide*, 2016, acrylic on canvas, 36 × 36 inches

*Schumann Resonance Rising*, 2020 acrylic on canvas, 30 x 40 inches

## CREATING ORGANIC SHAPES WITH YOUR BRUSH AND MORE

The size and shape of your paintbrush impact your mark-making.

Round brushes are great for making movements that feel like you're drawing. It's fun to use this brush as you would a charcoal pencil, making loose, linear, gestural movements.

I like using bright (square-top) brushes. The lines they make are thick and the marks they make are squarish. I enjoy making dashes or dots with this shape of brush. They're also good for covering larger areas on the canvas.

You can use a rigger brush (a long, thin, pointed shape) to create long skinny lines or swirling curves and circles.

The Princeton Artist Brush Co.'s line of Catalyst tools and brushes includes silicone contour tools, like a wedge-shaped spatula that's great for making flat passes of color. They're a cool alternative to palette knives, and they add a different energy to a painting.

Even old, out-of-shape brushes have their use. Instead of tossing these brushes, use them to create organic patterns by pressing the brush to the canvas again and again. Or see what kind of funky lines they make.

As you get closer and closer to finishing your painting, let the details in the main area of interest become smaller and smaller. You can use a small paintbrush or paint pens. Just as a Russian doll set fascinates us with its progression of ever-smaller dolls, your details will draw the viewer in and ramp up their curiosity. Large shapes move the eye across; tiny details draw the eye in closer

to investigate. In this way, you're guiding the viewer exactly where you want them to go. This is another way to find resolution with a painting where you feel stuck and unsure—unlike my earlier suggestion to block in large shapes, try making tiny marks in one area and see if that resolves your painting!

Another interesting way to add details is to peel dry paint off your palette and attach it to your painting using gel medium. Or use gel medium to affix collage paper! That's the beauty of working in acrylics. It can quickly lend itself to mixed-media applications and other water-based material. Know that you are only as limited as your own imagination.

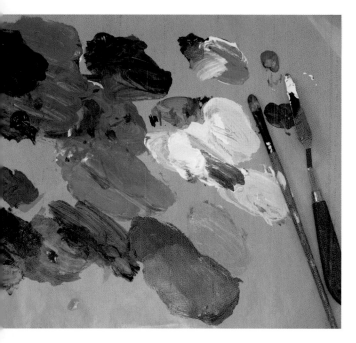

You can even scrape dried paint off your palette with a palette knife to incorporate as textured details in your painting.

## A Word about Substrates

A substrate is the surface that an artist paints on. As you may know, there are a variety of substrates to choose from: low-, mid-range, and high-end stretched canvas, gessoboard, clayboard, wood panels, stretched linen, canvas paper, and more. Which one should you use?

The answer is that there is no one best substrate—there's only the one that you prefer. Over time, try out different substrates and note how the smoothness or rough texture impacts your painting process and results. Does one substrate seem to make your paint bead up and stay wet too long for your liking? Do you prefer the lack of give that you experience when painting on a board? It's important to experiment. You will likely discover one or two substrates that make painting a pleasure—those are your go-to substrates.

I do think that you get what you pay for when it comes to selecting a canvas; that being said, having the greatest materials will not guarantee a great painting. Even inexpensive canvases can be used to make good art (you just may need to add more layers, due to the nature of the surface). I think that painting is a lot like cooking—a good cook can make do with whatever ingredients they are handed.

*Invitation*, 2020, acrylic on canvas, 24 × 36 inches

# HOW TO MAKE YOUR ACRYLICS LOOK AS VALUABLE AS OILS

# WORKSHOP 16

## Texture Applications

Texture makes your paintings more interesting and three-dimensional, as well as more valuable. Imagine a buyer shopping for a new home. The first house they visit is a ranch and the walls are plain white. The flooring is pretty much the same all over this one-story house. This house is serviceable, but not fancy. The next house they visit has several stories. This house has beautiful wood trim and balconies. The countertops are smooth, shiny marble. Some rooms have lush, plush carpet and other rooms feature glossy hardwood floors, all adding to the texture and feel of that house. Some walls have velvet finish and are soft to the touch. Other walls in the house have stucco paint, and there is a rustic stone fireplace. You could get lost in the house discovering hidden nooks and secret passages! Which house would cost more—and which home would a luxury home buyer be happy to pay more for?

I want you to adopt that same perspective with your artwork. You're going to build a "house" with fascinating floors stacked on top of each other with details that delight.

On the following pages are a few great ways to add texture to your acrylic paintings.

## HEAVY GEL MEDIUM

When I started incorporating heavy gel medium into my art process, it was a complete game changer. People look at paintings with the 3D texture from heavy-body gel medium and they say, "*Oh, I want to eat this painting! It looks so yummy.*" It must be because the gel medium transforms your paint into frosting! Fans would comment that my paintings looked edible; it was very pleasing—mostly because it indicated that my paintings were being "consumed" beyond an intellectual level. The viewer had an immediate, visceral connection that they were able to put into memorable words. When was the last time you proclaimed that a painting looks "tasty" or "good enough to eat"?! Last, but not least, these comments provided valuable feedback early on in my career as to what made my paintings stand out online. Heavy gel medium is a thick paste that you can add into your acrylic paints. When it dries, it retains the texture (including stiff peaks) with a glossy finish. I like to mix equal parts of paint and gel medium using a palette knife.

Rather than using this technique all over your painting, I suggest creating pockets of heavy gel medium texture for greater impact.

I like to premix my concoctions of heavy-body gel medium and paint on a disposable palette paper using a palette knife. I can build up the consistency as thick as I like, and then lift it up in one fell swoop. Unlike a brush, the knife can be wiped perfectly clean with a rag after you apply the paint to the canvas.

## SPRAY PAINT

Spray-painting is not the smelly, messy, outdoor activity that you recall. Water-based indoor spray paints sold today are safe and fun to use! These paints, like tube paints, are labeled with information about their relative opacity.

Using spray paint is a great way to add texture to your paintings. The texture of spray paint is super soft, and it allows you to produce areas of interest on the canvas. Use spray paint to make curves and lines, to cover over an area, or to create shapes. If you hold the nozzle extremely close to your canvas, you'll get a finer line or you can hold it much farther away to apply a diffuse area of color. Get some spray paints and experiment!

## ACRYLIC INKS

Another great tool in my texture arsenal is acrylic inks. These are different from alcohol inks; these are actual acrylic pigments. You can work with them the same way you use alcohol inks, but I use them interchangeably with paint.

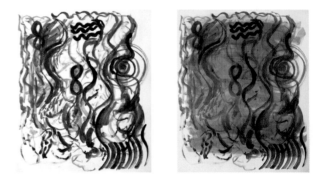

On the left is a study of marks made with acrylic paint, and on the right, a glaze of red acrylic ink layered over it.

I like to drop pigment into certain areas, moving the ink dropper like a paintbrush. Sometimes I let the ink drip and flow, adding spontaneity to my practice.

As you know, acrylic paint dries darker than it appears when it's wet. I like to use acrylic inks in conjunction with acrylic paints because the inks are densely pigmented and don't fade much after drying. Buy a few colors and try them! I don't paint exclusively with inks, but I tend to keep one or two bottles on hand while painting. They can also be used to create glazing effects, as in the examples on page 121, bottom right.

## OIL PASTELS

I like to use oil pastels to create finishing touches on my paintings. They are a great way to brighten an area of color; oil pastels are pure, saturated color. They also provide a luxurious texture that is very appealing. (See an example of this on page 78.) You can also draw with them. Some pastels are durable and easy to use, like crayons, while more expensive brands go on like butter and are rich and creamy. However, you need to use a fixative with these, because they will literally never dry. (Also it is best not to use acrylic paints or inks over the oil pastels, as the oil will repel acrylic and make it peel off.) ∎

"**Don't rely on any one texture technique— mix and match them to add even more visual interest to your paintings.**"

# WORKSHOP 17

## Glazing

Glazing has traditionally been used in oil painting. Hundreds of years ago, it was the only way to get consistent and vibrant color because of the art materials they had at the time. Artists would first create an opaque underpainting and then they would glaze it again and again and again by applying thin layers of transparent paint, increasing the richness and the depth of the colors. Today, we have glazing media at our disposal and we get to easily do the same thing in our acrylic work.

You can use glazing at any stage of the painting process, in several different ways:

- You can glaze one area of a painting.

- You can glaze a painting but then remove some of the glaze. Let's say there was an area of yellow that you glazed over, but you wanted the yellow to be more visible. While the glaze is still wet, simply rub off the glaze in that area with a rag. You can add interest and visibility to areas where you've removed glaze by outlining the area with a paint pen.

- If you have a painting that doesn't seem cohesive, try an all-over glaze to unify the painting while not obscuring the details.

Here is a small study that illustrates glazing. The blue brushstrokes are visible beneath the transparent layers of yellow on top. With a damp cloth, I removed some of the glaze in the middle, revealing the initial strokes. This push-and-pull technique is fun and simple to create while you enjoy building up the layers in your painting.

## The Key to Achieving Depth in Your Paintings

Going back to the house metaphor: If you have an eight-story house, it's probably worth more than a single-level house, right? The same goes with paintings: By adding layers of both transparent and opaque paints, you can create a deeply layered, more valuable painting, the type of painting that viewers can stare at for hours, as they get lost in the layers.

As you paint, be sure to check to see that you're creating an interplay with both opaque and transparent paints. How many levels does your "house" have? If it's too few, keep layering!

Use all the elements of making your acrylics look like oils through steady application of and experimentation with new materials.

## STEP OUTSIDE YOUR COMFORT ZONE

Use all the elements of making your acrylics look like oils through steady application of and experimentation with new materials.

The painting on the opposite page was created during the chilling start of a New Jersey winter. I still remember how uncomfortable it felt to complete this painting because I was stepping outside of my normal color palettes. The meek, opaque gray and blues felt reflective of my mood. But I decided to accentuate the void at the center by surrounding with warming tones. After a few days of contemplation, I decided to take a risk and glaze a magenta geometrical shape that began in the middle, carrying it off to the right side. This moved the viewer's eye in the direction I wanted, completed the composition to my liking, and added a pop of color in a more definitive way for me. ■

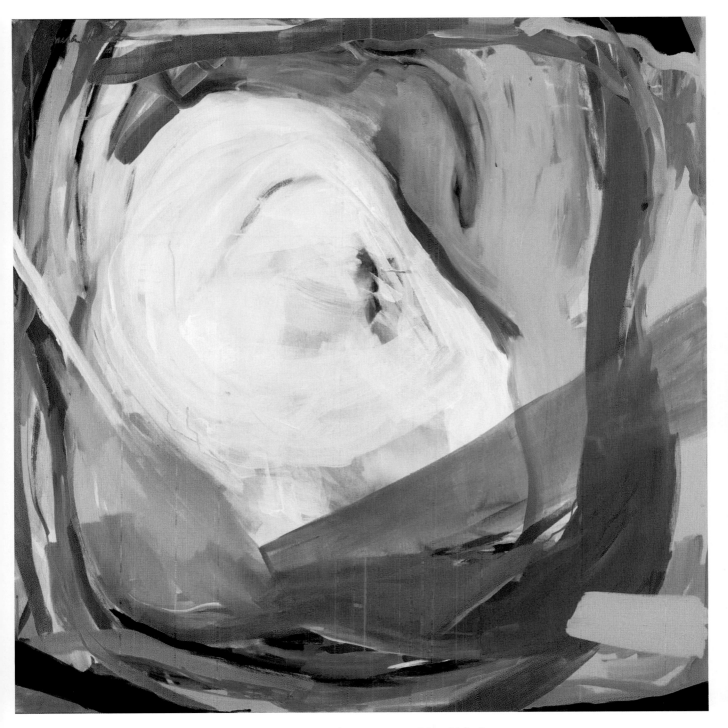

*Vernazza*, 2016, acrylic on canvas, 36 × 36 inches

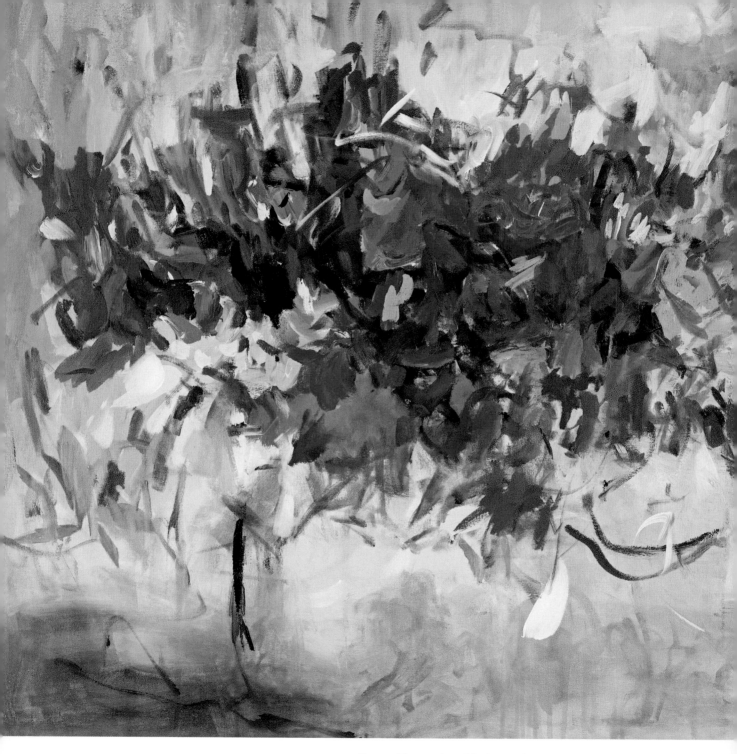

*Crown Expansion*, 2019, acrylic on canvas, 30 × 40 inches

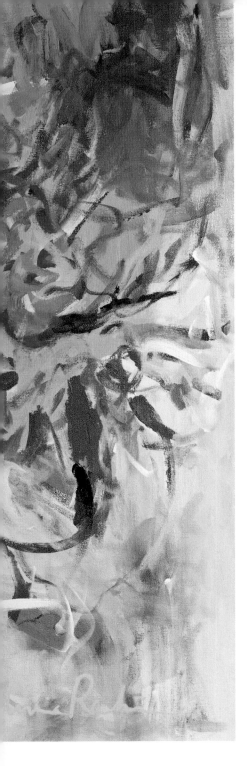

# CHAPTER 7
# BRINGING IT HOME

# WORKSHOP 18

## Styles of Abstraction

In this section, I want to walk you through two demos, as if we were painting together at an art workshop. Often my students will ask me if I have a composition in mind when I start a painting. Here, you'll be able to get a sense of the spontaneity and thought process behind an intuitive style of painting.

For the first studio session, I work on two 24 × 24–inch canvases at once. The goal here is to take risks and loosen up. While one composition is midway and drying, I can take that energy and transfer it to another blank canvas to see what else wants to come through.

### CHASING THE HIGH

The first demo is an example of "chasing the high" in a painting. I start with fine linework in my darkest hue, and then piece together a composition to a sunny, bright finish line—one brave layer at a time.

I load up a dry round brush with a bit of Prussian blue and purple. I use wide, big strokes in a jagged but circular motion. I scribble along the rest of the canvas, varying between big, open, flower-like shapes and tighter ribbons of color trailing off.

Using a bit of water and a round brush, I start to fill in certain shapes. I work quickly and on both sides of the canvas so as not to get too tight in one area. It's easier to start off loose and tighten up later than it is to work the other way around.

I apply thick layers of magenta paint where I want to add a hint of a flower bud. I repeat certain lines around the circles to help accentuate their importance. I decide to block out more of the canvas with magenta. Still keeping the layers transparent, the initial strokes peek through as a gentle guide in case I get lost down the road.

Now I work in some glowing greens and yellows on the opposite side of the canvas. I use transparent viridian green to tie into the greenish Prussian blue underneath. And for the layers above, I have more opaque greens with a hint of fluorescence.

Realizing that both my hand and my heart want the composition to be more floral, I start to block in shapes. I draw in loops of a flower in yellow at the top. I fill in areas around the canvas with yellow pockets, blending in some parts of magenta to get orange tones. At this stage, it feels unsure, off-kilter. But the "ugly" stage of a painting is necessary. It's like putting together a jigsaw puzzle, except you have no idea what the final picture is "supposed" to look like!

I make a few more changes—adding a few light blue marks here and there, pale orange to the upper left, and a swath of pink to the middle left. I then decide to leave the painting alone for a few days. Keeping it in the center of a space I pass every day, I am able to reflect on and really "live" with the painting. I enjoy the attractiveness of a flower forming in the middle. But, ultimately, I know that I am willing to "ruin" this one and push further.

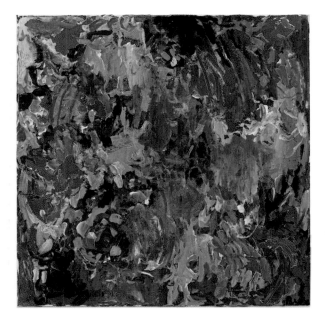

After a few days of detachment, I return and arrive here. I love this color palette and the eccentric way the fluorescents bounce around the purples and teals. For me, it feels exaggerated and "out of this world" in a bohemian kind of way. Many times, those last-minute "strokes of genius" may quickly bring a painting to its completion. I title this work *Sunny Escapes*.

## COLOR IMMERSION

At the start of this demo, I only knew that I wanted to create a deep blue painting. Because I started with a concept based on a mostly monochromatic color scheme, the composition came together easily. You can experiment with busier paintings, and then switch up to flowing, simpler styles like this when your mind needs a rest. ■

Using a palette knife, I mix in a little bit of heavy gloss medium and Prussian blue to start. I spread this onto my canvas with the palette knife, keeping my movements as expressive as crashing waves.

Taking my flat brush, I complicate the composition even more with wild, spontaneous linework and dashes in the upper-left corner. There are hints of dioxazine purple as well.

I rotate the canvas clockwise to get a different perspective on the composition. With the purple still wet on the canvas, I mix in a bit of white and start to bring in opacity. I choose a muted green to incorporate around the surface, since we are already working in opaque colors. Noticing a natural horizontal flow, I take a smaller brush and add flashes of hot pink detail from left to right. I keep my brushwork loose and playful but strong enough to support the overall movement of this piece. I then break up the horizontal energy with a few pops of yellows and oranges.

Rotating the canvas clockwise again, I add more viridian green tones throughout. I want this painting to feel darker and moodier, compared to the painting on page 129.

Now I add more dark blues to the center and lower-left areas to create a feeling of depth.

I rotate the canvas counterclockwise and add swaths of green and yellow. Then, once again, I decide to let the work sit for a few days. I enjoy the vibrancy of the blues against the colorful pops of color. But I know I don't like the muddiness and disharmony of the bottom half.

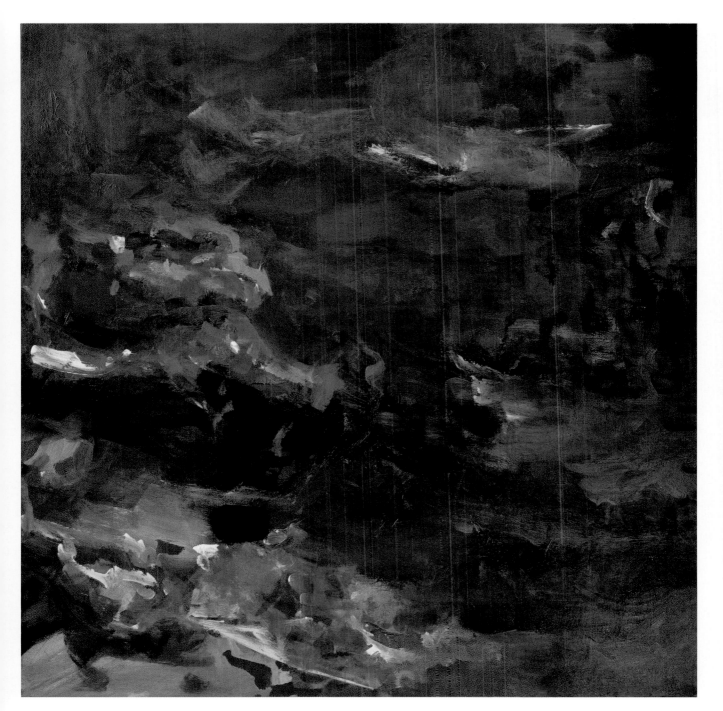

In the end, I use glazing and lots of editing to simplify
this piece and focus on the areas I love the most,
tuning out the rest.

# WORKSHOP 19

## Final Steps

It is easy to finish a painting and want to quickly sell it. But seasoned artists know that completing a painting is just half the process. First (for abstract paintings), you need to finalize the orientation of the painting. Then you need to decide where on the canvas (and with what tool) you will sign the painting. You will have to come up with a title, if you did not have one in mind along the way, and then you may want to varnish it, possibly frame it or otherwise finish the edges, and then, when it sells—safely pack and ship it to galleries or collectors. We will discuss pricing in Workshop 20 on pages 139–44.

### CHOOSING THE ORIENTATION

Abstract art, unlike representational art, can be oriented in any of four different directions; the side that was the top when you were painting it may look better if you hang it so what was the top is now the bottom of the painting, or rotate it to one of its sides. So make sure you view your painting with each side "taking a turn" at the top. Sometimes photographing a painting with your phone and then rotating the image and looking at it that way is helpful as well. Do you have a clear preference? Note that if you have a dark area, you should place it at the bottom rather than the top because it makes sense to the viewer's eye—dark colors have more weight than light colors, so orienting dark colors at the bottom gives a sense of gravity at work.

Consider how the viewer's eyes will travel across the painting. We generally read from left to right and top to bottom. And our eyes are first drawn to the darkest areas of a painting. Are there elements in the painting that are guiding the viewer's eye on a journey? If so, does the orientation need to change to make that journey easier and more comfortable?

Especially with square-shaped paintings that are well-balanced, the final position may look good in any of the four orientations—or sometimes one looks better than the rest (see *Grace*, on the opposite page). I recommend rotating your canvas multiple times throughout your painting sessions. You will usually have an orientation that feels like "home" when you land back on it. ■

Opposite: *Grace*, 2017, acrylic on canvas, 30 × 30 inches. Deciding which orientation to sign and publish your painting is often subjective. Because this painting is mostly dark purple, I know that the white square chunk juxtaposed with the dark purple center becomes the immediate focal point. The combination also creates a sense of "weight" on the canvas. In version 1 (which is the version I went with in the end), notice how your eye moves from left to right and lands securely at the white space beneath. The patch of white feels like an anchor—holding the rest of the composition in place. By contrast, in version 3, the white block hangs in the upper-left corner, almost like a cloud.

Figure 1

Figure 2

Figure 3

Figure 4

**There is no right or wrong answer when it comes to abstract orientation, and it as subjective as the colors you love. When it 'clicks,' it just clicks.**

## SIGNING YOUR PAINTING

Once you've established the orientation, it's time to sign your painting. Artists typically sign in the lower-right corner, but I've done it in other corners based on compositional elements. Some people also add the date or year. You'll want to sign your painting using a paint color that contrasts with the area where your signature will go, so that it'll be visible. But keep in mind that a signature in a very bright or dark color will move the eye toward it, depending on what else is around it, so your signature can play a part as an element of the composition, too.

When I first started selling my work online, I thought I had to sign my name the old-fashioned way. And then I quickly realized after a few failed attempts how difficult it is to write my full name with a finicky paintbrush—it is no fun at all. Luckily, as acrylic painters, we can make use of paint pens! I like to use Posca markers or Amsterdam acrylic markers (acrylic paint pens), or Krink markers (these are alcohol-based paint). No matter which pen you choose, be sure that the tip is primed and flowing before you attempt to sign your name—it may be a good idea to do a practice signature on a separate surface before you try it on your painting.

Sign the Back! Using the same marker, write your name clearly on the back of the canvas, along with the year and the painting's title. This documents your work and ensures that this important information will stay with the artwork for years to come.

## HOW TO TITLE YOUR WORK FROM WITHIN

The titles of your paintings are an important tool for you to use to communicate your message to your customers. There are many things that you likely withhold from the public eye that can be expressed by your paintings. So while being newly in love or going through a divorce may be rocking your world, you might not share that with the world on social media—but your feelings about these life events can be expressed in your art and obliquely referred to in your title. The title can help the viewer see the painting in a way that is closer to how you see it.

Here are some suggestions for how to create interesting, compelling, and true-to-you titles:

- If a title comes to you, paint into it. If a title comes to your mind like a bolt out of the blue, keep that title in mind as you create a new painting. Having this title in mind will guide your painting's development.

- Look at your painting when you're halfway done—or completely done. What does it make you think of? What do the colors evoke for you? Does it bring up any memories? How were you feeling at the time you made this painting?

**Opposite:** *Cabbage Patch Kids*, 2019, acrylic on canvas, 30 × 30. The painting celebrates the joy and playfulness of the inner child, so I signed my name with a red acrylic paint pen, as I liked the pop of red against the green. Take a look at examples of my signatures on my finished paintings throughout this book, as well as those of artists whom you admire.

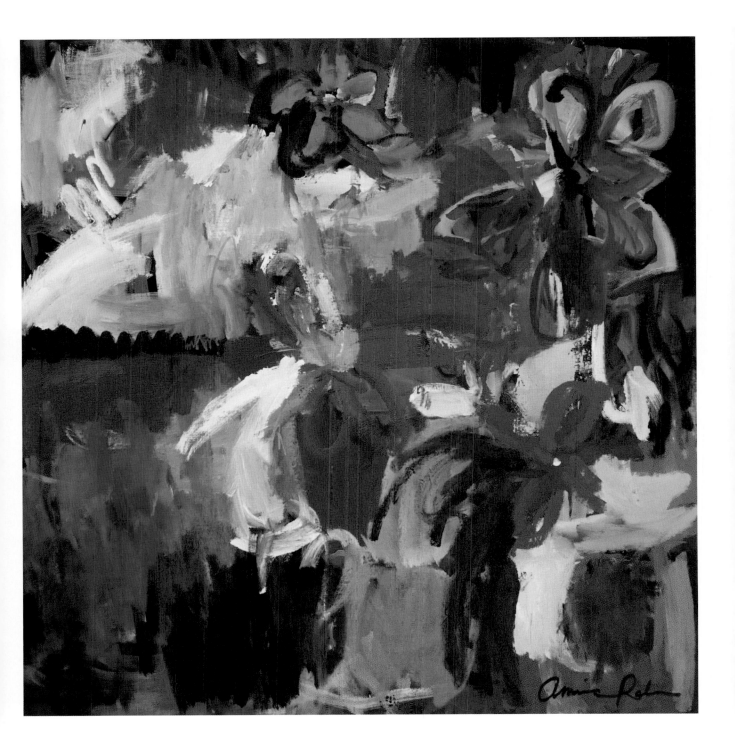

Bringing It Home  **135**

- For example, one of the artists I've mentored showed me a painting that seemed a bit dark and broody to me. When I asked her what the painting made her think of, she said, "the galaxy." My view of the painting completely shifted at that moment!

- Another artist showed me a painting and told me it made her think of the Easters she celebrated as a child. She recalled colorful, frilly dresses and hunting for Easter eggs. When I pointed out that a traditional Easter color (yellow) wasn't present in the painting, she decided to consider adding it—a good example of how you can make changes to a completed painting based on the title you've chosen.

- Yet another artist showed me an abstract floral painting and told me that it made her think of a wedding. This is the kind of theme you could build an entire series around! The artist decided to title it *She Caught the Bouquet*.

- When I look back at the titles of my past artworks, they read like miniature journal entries to me. While the customer may understand the general feeling I'm communicating through the title, I'm brought right back to my life at the time of the painting, the way I felt, and what I saw in the painting.

- Even if you're just beginning your art journey, give your works titles that offer the viewer a peek into your artistic mind. Just like painting, titling artwork is a skill that we develop over time.

## Varnishing, Framing, and Packaging Your Work

After you're 100 percent sure your painting is dry (including the signature, but excluding any oil pastel details, as oil pastels do not completely dry), you can varnish it. I often wait until the painting has sold before I varnish it. Why do we varnish our work? Varnishing protects your painting from damage from being touched, from UV damage, and from humidity. It doesn't make your painting waterproof, but it can provide some level of protection from water. Varnishing also gives a uniform finish to your painting—if you have a mix of matte and glossy paints in the artwork, this will no longer be apparent.

Some people do "isolation coats," which is a coating that is put on before varnishing. This protects the painting if the varnish ever needs to be removed, such as during restoration. I don't worry about this with my work.

Use a high-quality liquid varnish, such as Liquitex or Golden. The varnish can be satin, matte, or gloss—whatever your preference is. Practice using it on a painting you don't care about so you can test how the varnish works and looks.

*New Beginnings*, 2016, acrylic and mixed media on canvas, 36 × 36 inches. This painting was created over seven years ago in October, in the attic of an old house in New Jersey. I vividly remember how engaged I was in the challenge of it all. While the lower-center section has wild, intensely colored brushstrokes, the reminder of the painting is muted and still. *New Beginnings* marked a period of death and rebirth in my life, leaving a three-year relationship, moving to Mexico, and becoming a real business owner. I could not have known that this painting would go on to become one of my best-selling images to date.

Use a large, soft, flat brush from the hardware store as your varnishing brush—varnishing will be its sole function. You can put the varnish in a bowl or you can pour it directly onto your painting. Brush the varnish all over the surface in thin strokes. When you think you've covered the entire surface, look at it from the side so you can see light reflecting on the wet varnish. Have you missed any spots? Once the varnish begins to dry, don't add more! The varnish becomes sticky as it dries, and this can lead to a mess. Just do one pass of thin varnish in one go. Keep the piece flat while the varnish dries, or else gravity will make the varnish drip and dry with visible runs. Wash the varnish brush thoroughly so the varnish doesn't dry in the bristles and wreck the brush! (Most acrylic varnishes can be cleaned off of your tools with soap and water, but check the instructions on the varnish label to be sure.) Make sure the varnish has had a few days to dry before handling or packing the painting for shipping.

When it comes to packaging, you'll do it in different ways, depending on the substrate. If you're packaging a work on paper, then you will roll it up and put it in a tube. If you're packing a work on gessoboard it is super easy to ship because it's a hard object. You need to protect the corners with extra bubble wrap so they don't get dented. With an artwork on canvas, you're going to make a sandwich: Put a layer of foam core on top of the canvas and another layer of foam core beneath the canvas. This sandwich adds to the stability and strength of the canvas and protects it during shipping. Put a layer of bubble wrap all around the sandwich. (If the work is framed, you should protect the corners with cardboard frame protectors, which are available at some shipping stores or online.)

Your wrapped artwork will then go into another container with more packaging material around it—a container within a container, for the best protection during shipping. You can package it yourself or hand your wrapped artwork to a shipping clerk at the UPS store or another shipping company with instructions for how to package it further. Don't ever hand over a bare painting to the shipping person and say, "Here, please ship my painting." They may be experts in shipping, but they don't know the special steps needed for shipping artwork. So please do the first steps yourself.

## Framing

Framing is worth mentioning here as well. I've experimented with offering framing options to customers on my site. However, it's usually not necessary. You can paint the sides of your painting in a way that suits the piece and brings it all together. Collectors usually choose to frame their paintings on their own to match the moldings, furniture, or decor in their home. If you have a gallery exhibition or are invited to show in another type of venue, you should follow the guidelines that they recommend in their establishment.

# WORKSHOP 20

## Pricing Your Work

Pricing is a tough subject for many of us. It can be so tempting for emerging artists to underprice their work! But keep in mind the psychology of buyers: Humans often judge the value of something by its price. So if your painting is $45 and another artist's painting of the same size is $295, buyers will think that your work is amateurish and not particularly special. They'll assign greater respect and value to the pricier painting—and none of this has anything to do with the art itself!

When we price our paintings, we imagine possible pushback. We imagine people scoffing and dismissing us. The thing is, those things will happen to artists no matter what price they put on the painting.

Your time and expertise have value. Don't diminish them by underpricing your work! Even if you feel like the new kid on the block, it's important to enter the space with a price that communicates your self-value and self-respect. Not only that, the price should allow you to continue profitably in your art business! You have overhead, sales and marketing costs, taxes, and materials costs—all of which eat into your profit. Your sales price is like a pie, and, unfortunately, many "slices" of the pie are already spoken for! Create a big enough price pie so that the slice that remains for you will sustain you.

Here are some of the things I've learned about pricing.

### THERE'S NO ONE-SIZE-FITS-ALL FORMULA

You can read the "commandments" on pricing your artwork and still walk away feeling confused. Should you price it by linear inch? By square inch? By time spent on creating it? All of these are ways that artists and some galleries come up with their prices.

The soundest approach I've found has been to charge by size. This keeps things fairly consistent and makes the most sense to your customers. It also helps you ascertain the price of a painting pretty quickly and objectively, which is important as you start to produce more and more work. You need to decide if you're going to price it by linear inch or by square inch. The best way is to just do your research.

When I was working on my pricing structure, I calculated the costs of several paintings using each of these models and then decided on the one that works best for me.

### THE AVERAGE PERSON DOES NOT UNDERSTAND THE VALUE OF ART

This includes us artists! Unless you've spent your formative years attending art auctions, learning art history, and mixing with the upper echelons of

society, you probably don't understand the value of art. And even if you did, you'd still probably be baffled by the astronomical prices some works of "modern art" command these days. This is really important to understand as an artist, because it means that it's our job to show people the value of art. Help the buyers understand that when their designer bags or their Louboutin heels become shabby, due to wear and tear or go out of style, their art collection will still be hanging on the walls, warming the hearts of their family members for decades to come.

Art is the gift that keeps on giving, and it's one of the few things that usually appreciates in value. If you see a piece of art that you love, and you see that the artist is serious about his/her career, then chances are, the price that you're looking at today will increase if not double in a year or two. But it's a shame that some people still try to bargain down the price of an original painting. I was talking to an artist friend of mine recently, and she said something pretty profound: People would pay an artist more to paint their walls white, than they would be willing to pay for a painting. That's sad!

Have you ever discovered some really amazing art at a market or bazaar? You ask the artist about a painting you admire. She names her price, and you gasp inside, but try not to give away your surprise: She's about to sell you a fabulous piece of art that she conceived of and painted by hand for less than the price of a meal at your favorite restaurant. You're getting a deal! As you hand her a few bills, you imagine exactly where it's going on the wall in your home as the artist packs it up and thanks you from the bottom of her heart.

Once upon a time, I was that artist. When I first started selling my artwork, I stumbled. An artist who's new to selling can get so caught up in the excitement of doing what they love and getting paid for it that they don't have the foresight to think of it as a serious business. I'll never forget hearing on the *Fresh Rag* podcast that "*Hope is not a business model.*" And for many artists, that's all we have. We *hope* someone will want to buy our art. We *hope* they'll pay us in actual dollars and not other nebulous currencies, like exposure. The problem is, hoping for the bare minimum isn't sustainable. It doesn't work, because of the following:

- You will reach a point where the value of your art starts to exceed your earnings. This is one of the most exciting things about being an artist and a creative entrepreneur: Your work increases in value over time. And depending on how hard you're willing to work, you can close the gap pretty quickly. That's when you'll start to look at your prices and say to yourself, *My work is worth more than that—I'm worth more than that.* Now a painting that you were once willing to sell for $300 will be sold for three times that amount, and you hold firm on that price. The quality of your work increases. You're using finer materials and your customers are noticing. But, more importantly, you're noticing and you feel more confident in what you're doing. This is when you can raise your prices without owing anyone an explanation because your work commands it.

Do some online research to see what other artists are pricing their work at, and then crunch the numbers to come up with a formula that works for you.

## Researching the Market

One great piece of advice I found was to look at the work of some contemporary artists you like who list their prices, and work backward to calculate what formula (if any) they are using. I looked at several artists whose work I admire, including one abstract artist I love who has most of her work priced publicly on Saatchi. Within a few minutes of number crunching, I was able to deduce, "Oh, she's charging $1.50 per square inch." And then you can decide from there what your work can garner comparatively.

- Other artists will look at your prices. Remember that first point I mentioned above about doing your research. Well, other artists are doing the same. They're on your website or online store right now, figuring out your pricing method. And guess what? They have an opinion about your prices as well! I remember seeing an artist's promotion on Instagram quickly turn into a discussion about her prices. The artist was selling beautiful hand-painted original art for $30, framed! I'm happy if I can buy a decent pair of shoes for $30, so when I saw one artist comment and tell her flat-out that she was undercharging, I understood. The commenter, also an artist, told the posting artist that her prices affect us all. In other words, this artist got basically yelled at for saturating the market with below-profit price points. Her prices were too low, and a colleague was not afraid to let her know that this decreases the value of all art in the marketplace and makes it difficult for other artists to move their work at fair prices. But there's a flip side to this experience as well: Some artists will look at your prices and get angry because your prices are too high! We've all gone to an artist's website and thought, *They're charging [X-amount of money] for THAT?!* But you know what? If collectors are willing to pay what that artist is asking for, then they're doing something right. They've found their tribe, so get over it and go find your own tribe.

- Your customers will ask about your prices. This is a big one. Basically, you need to be able to explain why a piece costs that much. Not necessarily on its own, but in relation to your other work. That's why I like pricing by size, because I think it makes a lot of sense and is easiest to explain. I've met some artists who insist on charging more for one piece because they spent months creating it and it's so detailed, and they used unusual materials. Why should your collectors pay for your work habits? I believe that as you get better at what you do, you become more efficient, and the time it takes to complete a work should be independent of the price.

**"You can't please everyone—you need to have faith that there are buyers out there who will appreciate and value your work at a price that respects you and the time, effort, and money you've poured into creating it. "**

Some may disagree, but unless you're making jewelry one day and crocheting a sweater the next, I really think consistent prices for 2D art is the way to go. Some paintings take me months to create: I'm working slowly and exploring different options, and not all of them work as the painting evolves. But you know what? If I didn't love the creative process I wouldn't be an artist.

- Your pricing will change. You will change. Don't make excuses. This is my final point on pricing, but I think it's important. As most of us know, our passions and styles evolve over time. Our prices can and should change over time to reflect this. When you are raising your prices, don't make excuses. After all, when's the last time you pulled up to a gas station and the owner apologized for raising today's prices? Do retailers give a reason for their prices? Do we even ask? We know that H&M sells at one price point and Armani sells at another. We wouldn't think of asking the salesperson to explain the prices on the rack, so you don't need to explain why you're asking for a certain price. State your price and then shut up and smile. A good collector will see how fabulous you and your work are and be happy to pay what you deserve. And these are the people you want owning your art in the first place. ∎

## Putting It Online

Creating a website for your artwork is often the final and most daunting task of launching your business. After all, you need some form of a check-out page to collect any money for your online art transactions. Since art is often an impulse buy, you should make shopping on your online store as seamless an experience as possible. I list my prices. I have a "buy" button under every painting. And I include details about shipping, packaging, and delivery on my site to assure an interested buyer that their purchase is safe and secure.

In my experience, I've found Square-space to be the most user-friendly option for artists to get started. Another alternative is Shopify. Both allow for you to share a branded website of your work without having to compete with surrounding artists on the same platform. Deciding to sell your art online is as exciting as it is overwhelming. Do not hesitate to study examples of your favorite painters, ask questions in free Facebook groups and forums, and watch videos. Your website will go through many changes as you evolve and see more revenue to reinvest in your business. Just keep it simple, authentic, and remember that done is better than perfect in this case.

# WORKSHOP 21

## Bringing It Together and Evaluating Your Work

If you made it this far into the book, congratulations! You may have started to ask yourself: *How do I bring this all together? How do I combine everything that I just learned into my paintings and studio practice?*

Deciding that our paintings are good enough is often the hardest part. The real question is this: Can you now trust yourself? That's really the key here. Remember that no one piece is going to define you. You're going to be making a lot of paintings if you plan on doing this for the rest of your life. You don't need to be "better" than any other artist right now. You just need to offer your best at this moment—and also be okay with the fact that your best will change over time. Much of my work as a coach is helping other artists bring their work to a level of strength so that they can confidently start selling.

While present at times, fear is not necessary in our art practices. It's so easy to get attached to paintings in the creation stage, but I truly try to practice detachment until I am completely satisfied with the result. Basically, if it's good, I ruin it. I paint over it. I push on.

I ruin something good in order to get to something great.

It's a scary process, but it has paid off well for me artistically.

As a small business owner, I make a lot of decisions; often there's no clear right or wrong answer. It's mostly about seeing what works (or what doesn't) and then applying that insight to future choices. What works for one person's audience or clientele may not work for another's and I think it's important to keep that in mind when we're comparing ourselves to other artists and brands.

You can be successful and do it in a completely different way than other people in your same industry. And in many cases, you should. Be willing to be a unicorn. Go out on a limb. Take the road less traveled. It may take a bit longer to pay off, but it will always come together somehow in the end if you're doing it for the right reasons.

### CHECKLIST FOR EVALUATING YOUR WORK

Here is a quick checklist to refer back to when you're still unsure if you've done enough on a painting before posting it for sale. I promise, you'll get into your groove and feel more confident as the years go on. But as a good rule of thumb, the following criteria can help you get to the finish line and make your next sale.

**"You need to feel not only that your work is unique, but also that you deserve to produce the work that you want to make and be compensated for it. In order to effectively and convincingly market and sell your work, you have to have confidence in what you're selling."**

1. Mindset—Okay, so the first step in evaluating your work is your mindset.

   There are two aspects to this: Did I give this painting my best effort? And did I truly take risks and enjoy the result? Trust that paintings don't have to be complicated in order to sell. All you need to have faith in is the fact that people DO buy art and that your work is good enough. But if you don't have faith that that's all it takes, you're constantly going to either question yourself, question what you've just learned, and maybe question whether you should even be an artist anymore.

2. Test Your Colors—There are several ways that you should evaluate your colors.

   • Vibrancy, value, balance, and palette tests: Ask yourself, *Do I have clear vibrant colors and strong neutrals, or do my colors feel muddy and uncertain? Are my values strong and varied? Is there a balance of coolness and warmth?* Or, if none of those apply, *Is the color palette interesting?*

   • Emotion test: This is the hardest part and you shouldn't gloss over it. You have to think about the emotion behind the painting and be able to describe it. Otherwise, it may be difficult for collectors to connect to your work. You may have a hard time selling it because you don't even feel an emotional connection to it—so how can you expect someone else to? You may not feel a sense of pride or fulfillment when you're done with a painting, and if that becomes the norm, you may start to lose your momentum or even quit painting altogether. While I do not believe that you need to have emotion or inspiration to start a painting, I do believe that the act of painting can bring certain emotions to the surface, if you allow yourself to lean into them. You may not "feel" something every time you are completing a painting, but, in my process, nine times out of ten I can sense a shift in my energy when I add a big splash of yellow to my work, for instance, or if I suddenly incorporate pops of neons and sparkly mixed media. That emotion, no matter how subtle, can be used to title your work, or simply as a caption in a social media post.

   Look at your painting reflectively and ask yourself: *What do I want someone to feel when they look at this painting?* And if nothing comes to mind, post it online and invite your audience to share their impressions. Art can be a dialogue. Especially when you're feeling mentally and physically fatigued after hours of repetitious painting. The only emotion you may feel at the end is relief! Hah, and that's okay, too. Be your own cheerleader. Love what you do and what you've created. This translates in the way you present and even price your artwork.

3. Composition Test—In this important step, you will evaluate the painting's composition.

- Thumbnail test: Take a photo of your painting. On your laptop or desktop, reduce the photo until it's only about an inch and a half on the widest side. This is around the size that the painting will be when someone first sees it online on their phone (see also page 43). *Are the colors compelling enough at that scale to entice the viewer to click on it?* Look at this tiniest version of your painting and see if it's interesting, inviting, captivating, vibrant, and invigorating. If it's interesting at that tiny scale, then it'll do just fine online. *Sometimes shrinking the perspective of the piece gives your brain a chance to digest all that energy in a bite-sized amount.*

- You're going to look at the thumbnail you've already created and ask yourself: *What am I seeing on the tiniest level in terms of the composition? What pops out immediately?* This is a great way for you to test the focal point, the balance, and the weights.

- Mirror test: Take your painting, hold it up to a mirror, and see how your painting feels to you in reverse. If your painting works and it doesn't look lopsided or strange in the mirror, there's a great chance that it's balanced in terms of your composition. It doesn't have to look symmetrical. But when you look at it in the mirror, does it feel exciting and lead you on a compositional journey?

- Dance with the three *R*s (rhyme, rhythm, and repetition; see pages 94–95). This is the fastest way to create interest in your composition. Make sure that your colors rhyme, that they complement each other really well. Make sure that there's a rhythm or beat in your painting. Check for repeating little "notes" throughout that keep it cohesive.

4. Texture and Depth Test—Next, you're going to look at the texture and depth in your painting.

- This requires getting honest with yourself and asking: *Did I really put in the work in terms of layers? Did I try to add some type of texture? Does it feel textured? Does it have variety?* Finally, ask yourself: *Did I take a few minutes to add in some quick details?*

- A humbling but important question to ask is this: *Did I take risks?* A risk could be as simple as putting a little spot of pink somewhere. It doesn't have to be cataclysmic. Sometimes the risky thing for me is to add a bit of lime green in the corner or to add some gels and see what happens to the texture. Maybe

the risky thing is completely painting over a focal point and starting over with the composition. Can you identify one moment where you really took a risk in the painting? If not, chances are you're not going to impress anyone because you probably didn't impress yourself.

5.  TEST IT IRL!—I admit, this is my favorite part of getting a painting finished because it reminds me that creativity doesn't need to happen in a vacuum.

    - You can test the painting by showing it to the public. Put it online, put it out in the world where people can see it. Get it up on Instagram, post it on Facebook, and, most importantly, show it to people in real life. I don't mean your mom or your dad or your kids. It's probably not a good idea to show it in front of family, to be honest. They're not buying your art anyway. Skip your immediate circle of friends and take the painting out into the world. This could mean doing some markets, doing some shows, or going to storefronts and seeing if they would sell your work on consignment. You have to expose yourself to the real world in addition to social media.

6.  SELL IT!—Finally, when you're ready . . .

    - Ask for the money! And while you're waiting to get a buyer, keep going.

## Looking Back

I want you to take a photo of two to three paintings you love that you created during our time together. It doesn't matter how big or small they are; you just have to love them. Notice what the pieces have in common: Any similar colors? Brush movement? Composition?

Then go back to your "isolating your influences" journaling responses (see page 25) and compare how similar or different your paintings are to the work you were attracted to when you first joined me for this journey. No judgment allowed! Remember: You are allowed to change.

You're continually making a bunch of different work and you're testing it. This testing period is never going to stop. I'm still testing out ideas, and I love how much I learn from it. I have sold a lot of paintings that I didn't think were amazing or representative of my style. We will be on this growth journey for the rest of our lives. I want you to think about your art as something that's forever evolving. ■

## DEFINING YOUR MISSION

Earlier on, I asked you to look at your influences to come up with a general definition of your preferences and styles. You can quickly refer back to your notes as you prepare your mission or artist's statement. This can be for your eyes only, or you are welcome to share it on your website and with your collectors as you see fit. Writing your artist's statement is a great way to reflect on your art and what it means to you.

Here are some sample prompts you can use to start working with in your journal.

---

**MISSION/ARTIST'S STATEMENT**

Describe your work:

I use _____ [types of art materials] to create my paintings,

because _____.

You will find that I frequently use _____ [insert your

most-used color combinations] and I find that I resonate the most with

_____ [favorite color to paint with].

I explore _____ [insert the subjects, themes, emotions] in my

painting. [Elaborate on this as needed.]

I decided to become a full-time artist in _____ [year] but I've

been creative for much of my life. Some of the great Abstract Expressionist

artists of the past, including _____, _____, and

_____ [name your influences] are all inspirations for my process.

[Elaborate on this if you feel called to.]

Now it's time to discuss your mission:

- *Why do you paint?*

- *Why pursue your art in the twenty-first century?*

- *What does your work mean to you personally and what do you hope people feel when they see your art?*

Answer these questions as thoroughly as possible. Here's an example of my own mission/artist's statement:

I am Amira Rahim and I'm an Abstract Expressionist artist. I paint in water-based media—including, but not limited to, acrylics, enamel, ink, and oil pastel—to create my paintings, because I love the freedom of incorporating many materials in my work. You will find that I frequently use warm palettes and I am fond of magenta. I also resonate strongly with Prussian blues and other deep blue tones.

I explore the connections that color creates in the human psyche and the ability of color to affect our moods. I love to create work that is both visceral and sensual, feminine

and intentional. I do this by balancing the presence of the artist's hand with the nature of the materials in play.

I decided to become a full-time artist in 2014, but I've been painting and drawing for much of my life. My strongest inspirations in the realm of abstraction include Joan Mitchell, Claude Monet, and Willem de Kooning.

I enjoy using thick lines of paint and bright strokes throughout my paintings. Sometimes I will use texture and form to create a three-dimensional experience for my viewer. In every painting, my objective is to use color as a tool for self-evaluation. I want my work to be both confronting and comforting. I am greatly inspired by the information age upon us and the ability for the internet to connect us all. At times, there is hyperconnectivity and yet loneliness all at once. We can always return to art, however, for solace and reflection.

Art, for me, is a reminder of my humanity—a reminder that no matter how busy and chaotic life around me feels, my mental health requires me to paint and to enjoy making art on a regular basis. I want people to feel that soul connection when they look at my work.

# AFTERWORD

In conclusion, thank you for going on this journey with me. I hope you learned a ton and had fun in the process. While painting is a deeply personal and vulnerable art, deciding to teach others how to access this level of vulnerability has been even more eye-opening.

I know learning to paint can't possibly all be spelled out in a few words and photographs. Besides, that little bit of mystery to the process that is unspoken and unshown will allow you to discover more of the magic on your own. I know how much abstract art liberated me and the hundreds of artists I've coached over the years. And while many times I felt incapable of facing new limits, art gave me the spiritual strength required to walk courageously in my truth.

I am so grateful to the thousands of collectors my art has resonated with around the world. Many times, these collectors are first-time original art collectors and become repeat buyers. If any of you happen to be reading this book, thank you for your early support and patronage. I truly could not have done this without you.

And, finally, I want to thank the many mentors and sages I've met along this winding road of teaching and entrepreneurship. To develop a prosperous art business, invest early on in coaches and mentors you trust while you can. I enjoy teaching and connecting with artists immensely. It has been a lifeline to me at many moments in an otherwise solitary profession. I hope to connect more with communities of wild souls across the planet!

# ACKNOWLEDGMENTS

When I was first approached to write this book, my heart leaped to my lap. I was on the phone with a friend and could only describe this chance as "what I'd been waiting for my entire life." A week later, my maternal grandmother would take her last breath. On the other end of the country, my world split apart, and I nearly said no to the project. It would take many hands, months, and towers to get me here. Thank you for showing me grace when I needed it the most.

I want to thank Barbara Berger, my editor, for believing in the merit of my work and giving me the opportunity to put one of the most exciting things I've ever done into print. Thank you for helping me record the many dives and turns of abstract art into a published manuscript. Also at Union Square & Co., special thanks go to interior designers Christine Heun and Kevin Ullrich, and cover designer Igor Satanovsky; project editor Michael Cea; director of photography Jennifer Halper; and publisher Emily Meehan, for conceiving of the project from the outset. The little kid in me could not be more ecstatic!

I also would like to thank Kathy Cornwell for providing editorial support at the initial stages of this project. Warm thanks to Bridgette Lee, for happily coming to a tiny Scottsdale Airbnb in March 2021 and spending countless hours photographing and recording details of my painting process.

I want to thank my lifelong mentor, Jonathan Alston, my high school debate coach at Science High. Thank you, Jonathan, for your words of encouragement as I embarked on this project. My knowledge, drive, and resilience were cultivated greatly by your leadership.

Sincerest gratitude to Rachel Burch for lending her wisdom and much needed nurturing as I completed this chapter quite literally.

Heartfelt thanks to my assistant Mariana Gonzalez. I could not have done this book, coached hundreds of artists, and stayed true to my art, without your patience and unwavering loyalty these past few years.

And above all else, I would like to thank the many artists online and in person who've reached through the voids of social media to check on me, to laugh with me, and to encourage me to keep going. You make me smile, cry tears of joy, and inspire me to lean into my heart each day.

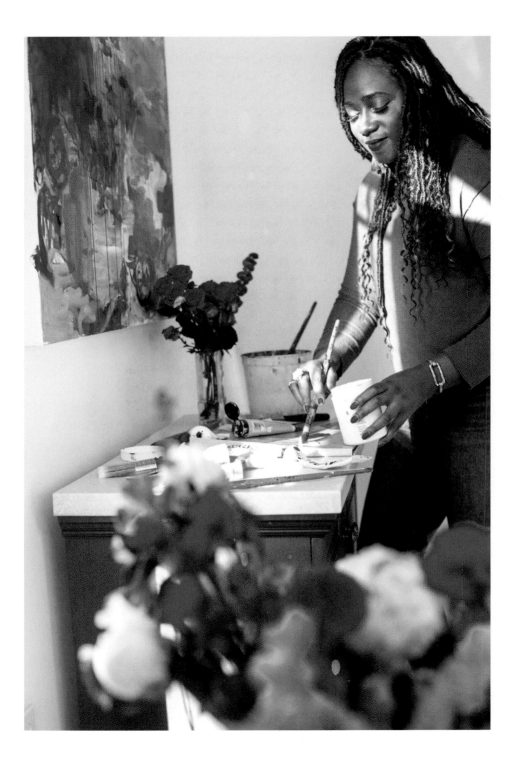

# RESOURCES

Below are some additional resources that may be helpful—books that continue to inform and inspire me, and websites and apps for artists' resources, supplies, and inspiration.

## BOOKS
Cameron, Julia. *The Artist's Way: 30th Anniversary Edition*. New York: TarcherPerigee, 2016.

Gikandi, David Cameron. *A Happy Pocket Full of Money: Infinite Wealth and Abundance in the Here and Now*. Charlottesville, VA: Hampton Roads, 2008.

Kleon, Austin. *Steal Like an Artist: 10 Things Nobody Told You about Being Creative*. New York: Workman, 2012.

## ART SUPPLIES
www.jerrysartarama.com
www.dickblick.com
www.michaels.com

## WEBSITES AND APPS
www.saatchiart.com
www.dailypaintworks.com
Pinterest
Etsy

And finally, to learn more about upcoming workshops and events, visit: www.amirarahim.com.

If you'd like to apply for my coaching program and intensive bootcamp, Better Than Art School™, visit www.amirarahim.com/better-than-art-school.

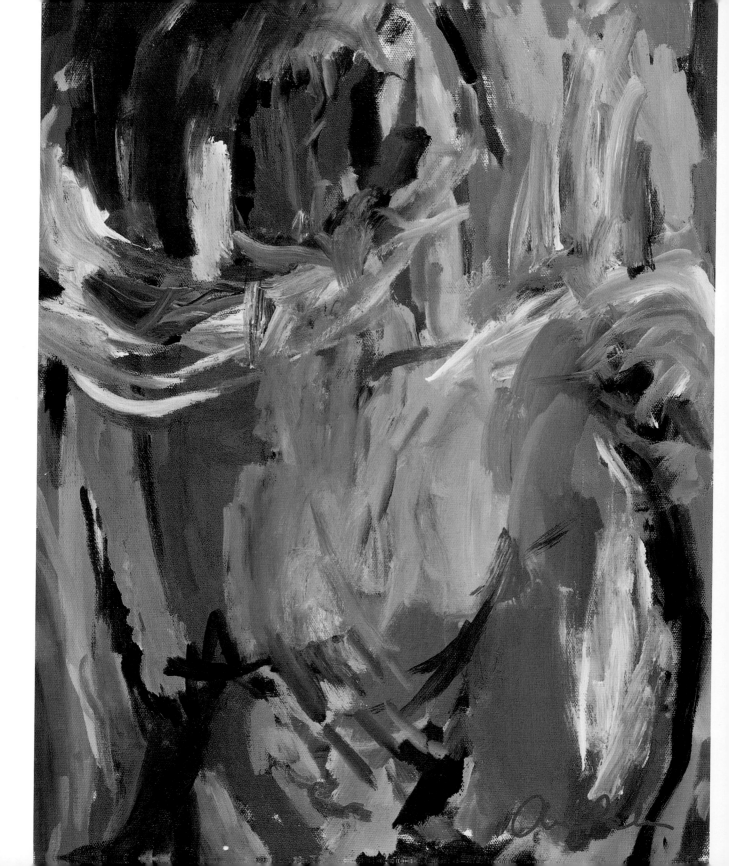

# INDEX

Note: Page numbers in *italics* indicate artworks and/or photo captions; page numbers in **bold** indicate Exercises.

# CREDITS

## QUOTE CREDITS

### "STUDY THE MASTERS," PAGES 20–21

**Richard Diebenkorn**
**Quote 1:** Burgard, Timothy Anglin, Steven A. Nash, and Emma Acker, eds. *Richard Diebenkorn, The Berkeley Years, 1953–1966*. New Haven, CT: Yale University Press in association with the Fine Art Museums of San Francisco, 2013.

**Quote 2:** Richard Diebenkorn Foundation, https://diebenkorn.org/the-artist/.

**Wassily Kandinsky**
**Quotes 1 and 2:** Kandinsky, Wassily, and M. T. H. Sadler trans. *Concerning the Spiritual in Art*. New York: Dover Publications, 1977.

**Mark Rothko**
**Quote 1:** Rothko, Mark. *The Artist's Reality: Philosophies of Art*. New Haven, CT: Yale University Press, 2004.

**Quote 2:** Ross, Clifford, ed. *Abstract Expressionism: Creators and Critics*. New York: Abrams, 1990.

**Joan Mitchell**
**Quotes 1 and 2:** *Joan Mitchell: New Paintings*. New York: Xavier Fourcade, 1986

**Jean-Michel Basquiat**
**Quote 1:** Gotthardt, Alexxa, "Jean-Michel Basquiet on How to Be an Artist," www.artsy.net/article/artsy-editorial-artist-jean-michel-basquiat, June 6, 2019, citing an interview with Isabelle Graw, 1986.

**Quote 2:** Hayden-Guest, Anthony, "Burning Out," *Vanity Fair*, April 2, 2014, bit.ly/3W4y7HU.

### "RED/MAGENTA," PAGE 54
Sources for artwork with red being more highly valued: www.artsy.net/article/artsy-editorial-history-red https://theculturetrip.com/north-america/usa/articles/these-are-the-11-things-that-make-a-painting-valuable

### "INSPIRATION IS OVERRATED," PAGE 105
Fig, Joe. *Inside the Painter's Studio*. New York: Princeton Architectural Press, 2009, page 42. Interview with Chuck Close, April 25, 2006. Source: https://quoteinvestigator.com/2022/08/28/inspiration/.

### "CHAOS AND ANGER," PAGE 111
Cameron, Julia. *The Artist's Way: A Spiritual Path to Higher Creativity—30th Anniversary Edition*. New York: TarcherPerigee, 2016.

## IMAGE CREDITS

**iStock/Getty Images Plus:** R.M. Nunes: 21; PeterHermesFurian: 39; Tetiana Saranchuk: 76 (spiral); Tatyanash: 76 (lines): undrey: 110 (wavy lines)

**Shutterstock.com:** Greenseas: 65

**Courtesy of Wikimedia Commons:** 77

© Marissa DeCinque: viii, 2, 6–7, 49, 95, 154; © Robin Koza: 24; © Bridgette Lee: 117, 121; © Laura Murphy of Laura Lee Creative: 14, 26, 106; © Lauren Payne: 103, 141

# ABOUT THE AUTHOR

Amira Rahim is a successful contemporary painter who says she is "on a mission to make the world a more colorful place." Her work has been acquired by collectors around the world—most notably by the Royal Family of Abu Dhabi. In 2013, she launched her art business and built a globally recognized brand with licensing partners in Australia, the UAE, North America, and Europe. Rahim's work has been featured in the *Chicago Tribune*, *Ebony*, *Professional Artist*, the *National*, *Time Out Abu Dhabi*, HuffPost, NBC's *Songland*, and more. She also mentors aspiring artists in her signature program Better Than Art School™. She currently lives in Phoenix. Visit her at amirarahim.com.